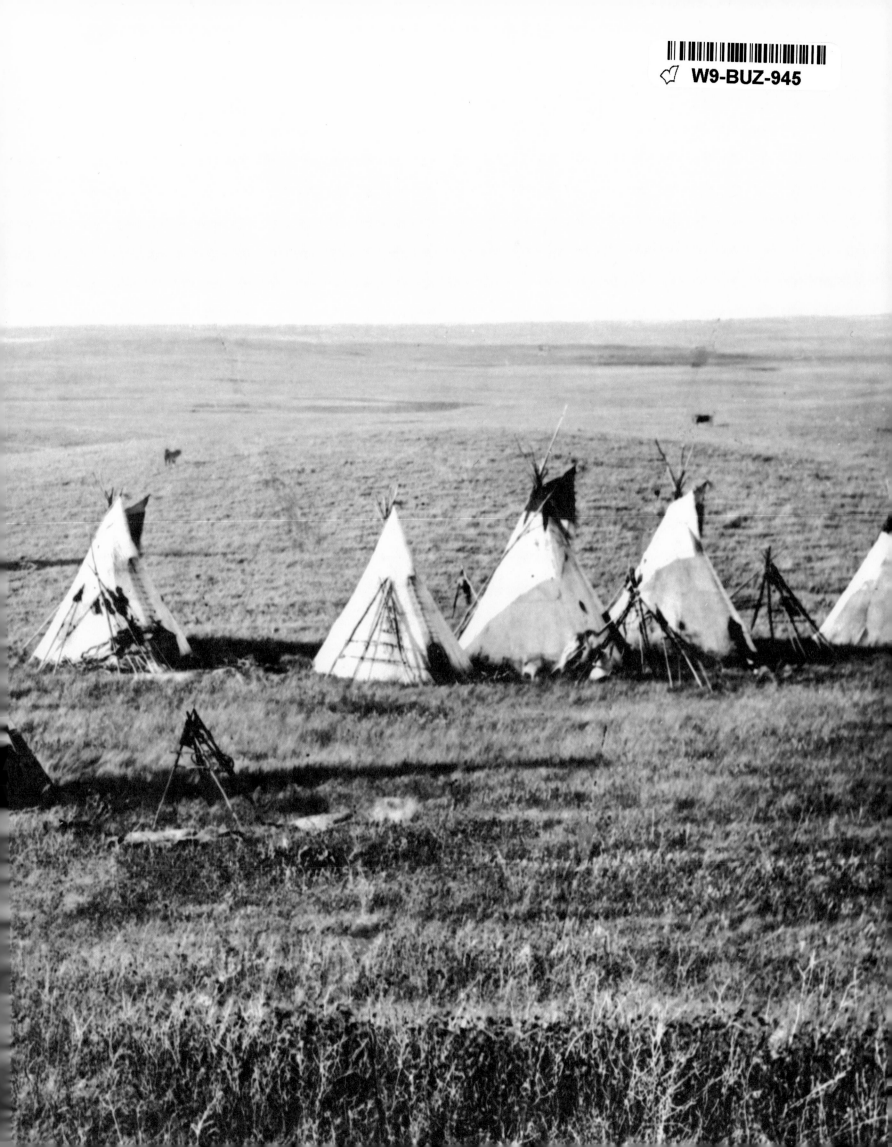

HISTORY IN THEIR BLOOD

HISTORY IN THEIR BLOOD

THE INDIAN PORTRAITS OF
Nicholas de Grandmaison

HUGH A. DEMPSEY
INTRODUCTION BY J. RUSSELL HARPER
FOREWORD BY FREDERICK J. DOCKSTADER

HUDSON HILLS PRESS
PRUDENTIAL PRESS
NEW YORK

Published in the United States by
Hudson Hills Press, Inc.
Suite 4323, 30 Rockefeller Plaza, New York,
N.Y. 10112

Distributed by Viking Penguin Inc.

Publisher: Paul Anbinder
Design: Nancy Grout
Typography: Vancouver Typesetting Co. Ltd.
Color separations: Herzig Somerville Limited
Printing: Herzig Somerville Limited
Binding: The Bryant Press
Printed and bound in Canada

Library of Congress Cataloging in Publication Data
Dempsey, Hugh Aylmer, 1929-
 History in their blood.
 Includes index.
 1. Grandmaison, Nicholas de. 2. Portrait
painters — Canada — Biography. 3. Indians of
North America — Canada — Portraits. 4. Indians
of North America — Canada — Biography. I.
Title.
NC143.G68D46 1982 741.971 82-6103
ISBN 0-933920-32-6 AACR2

CONTENTS

FOREWORD

The reputation of Nicholas de Grandmaison as a portrayer of the northern Plains Indians is well established among connoisseurs of western art. Working primarily in portraiture, he has preserved the likenesses of many of the peoples of the western plains area of Canada and the northern plains of the United States with a remarkable fidelity and sense of color. The Blood and the Stoney Indians (known as the Blackfoot and Assiniboine in the United States), among whom he chiefly worked, presented a character and dignity that fascinated him and that he sought to depict in his pastels. These today are to be found in many museums, galleries and private collections.

Any survey of the work of this talented artist inevitably includes comparisons with such peers as Catlin, Kane, Reiss and Kihn. De Grandmaison falls somewhat between the hard-line qualities of the latter two, but his approach is more academically sophisticated than that of Catlin or Kane. He developed his own style, and in so doing created an audience which to this day finds his portraits highly rewarding, both emotionally and esthetically. In the western art tradition to which he is most closely related, he represents the nostalgic mode well. He saw only the idealized Indian shadowed by the romantic past of the days of buffalo hunts and of war parties. In this his work is unreal, for he came late to the Indian world; very few people were left who had ever seen a bison wild on the plains, let alone hunted one. Even fewer men were veterans of the old war parties, and many people had begun to lose fluency in the native language. Indeed, it may have been these very facts that gave him such a sense of urgency; he realized that all too soon the Indians and their way of life would be gone from the northern plains.

Unlike most artists of his day, he did not work in oils to any great degree; he favored the subtle shading, texture and color combinations that could be achieved with pastels, and used them almost exclusively. Ordinarily one would expect this choice of medium to affect the price of his portraits, for pastel has never enjoyed the same regard for permanence and market value as oils. Yet de Grandmaison was well paid for his paintings throughout his career and was able to find buyers who considered his work well worth the price.

The man himself is something of an enigma, an eccentric who was never really well known during his lifetime. He gave little

thought to others and imposed upon the hospitality of friends and the Indians who sat for him, yet he seems always to have retained their friendship. Perhaps they valued the high quality of his art to such an extent that they were willing to overlook his eccentric manners while enjoying his superb esthetic expressions. Tireless in his painting, de Grandmaison willingly underwent any hardship in search of new subjects — while often inflicting those same hardships upon others in his demanding requests for models or working space.

Judging from the records of his work, de Grandmaison had little interest in his subjects — ethnographically, historically or personally. He was obsessed by a romantic ideal rather than by the people who represented that concept. As a result, much of his work is not ethnographically accurate, but becomes a sort of Vision World painting, conjuring up an image long gone; and this quality is still recognizable in the faces of the people he portrayed. His strange indifference to the deeper identity and character of the Indians, to whom he was so attached emotionally and artistically, is difficult to understand. Furthermore, he evidently had little feeling for the misery of the Indians he visited, most of whom had known life only on the reserve lands. Nevertheless, de Grandmaison left to us the legacy of a colorful, dramatic and romantic picture of a world few have seen. Even today the northern plains Blackfoot and Assiniboine people are rarely visited by white people, and individuals from these tribes are encountered only at rodeos and pageants.

The art of Nicholas de Grandmaison has added greatly to our visual appreciation of the northern Plains Indians. This splendid collection of his work and the account of his life provide a valuable record of the artist among the Indians. For his devotion to a personal goal, his intensity and dedication to his art, and for his undeniable talent, we can be truly grateful. Those Indian people who sat patiently while he carefully recorded their faces and character in colorful detail still live, and will remain with us as long as art has meaning.

Dr. Frederick J. Dockstader

ACKNOWLEDGEMENTS

Several people have assisted in the research that has gone into this book. In particular, I wish to thank Mrs. Sonia de Grandmaison, widow of the artist, and Mrs. Sonia Szabados, their daughter, for sharing the family letters, files and their own reminiscences.

Early in the research phase of this book, it was decided that wherever possible the Indian subjects would be identified by the personal names used by their tribes; these names would be given both in English and in their own languages. Many native people have helped to identify the subjects of these portraits and have given information about the persons depicted. Jim Small Legs, or Buffalo Berries, was one of the few models still living. He spoke at length about his relationship with the artist. Others who helped were Vickie McHugh, my wife Pauline, Dave and Daisy Crowchild, John Samson, Jim and Rosalyn Shot Both Sides, Stephen and Queenie Fox, Howard and Mabel Beebe, Eleanor Brass, John Yellowhorn, Albert Yellowhorn, Horace and Aileen Gladstone, Fred Gladstone, Eddie Bad Eagle, Suzette Eagle Ribs, Antoinette Singer, and a host of others. Thanks also go to the Nakoda Institute, Stoney Reserve, for its list of Stoney names, and to Ian Getty for his help.

Thanks as well to Don Peacock, Manager of Public Affairs, Bank of Montreal, for providing copies of research files and encouragement from start to finish; to my own organization, Glenbow Museum and its director, Duncan F. Cameron, for permitting me to undertake this task; to my editor, Ruth Fraser; and finally, to that Great Spirit which permitted me the opportunity to have known and admired Nicholas de Grandmaison during part of his impressive career.

Hugh A. Dempsey

INTRODUCTION

Nicholas de Grandmaison was a romantic at heart and totally immersed in his admiration for the Indian. His contribution to Canadian art is rooted in his impressive portrait record of the native peoples of western Canada. His is the final chapter in a painting tradition that stretched from early exploration and pioneer days to the modern age.

The fashion of recording native peoples in a series of paintings was born during the early Victorian era when Paul Kane travelled westward from Toronto in the canoes of fur traders. Like the American artist George Catlin, he committed himself to the searching out and setting down of a pictorial record of the Indian peoples and their life patterns on their ancestral lands. Kane returned home after four years of wandering, bringing back hundreds of sketches made on the way. From them he painted the first great Canadian collection of Indian canvases; a hundred of them are still preserved in the Royal Ontario Museum in his native city of Toronto. These paintings both excited his own generation — who were thrilled by seeing exotic glimpses of the native peoples in their grandly varied homelands of prairie, mountain and forest — and inspired a whole series of artists to paint the Indian. Frederick Verner, Edmund Morris and James Henderson were but three who each added his individual contribution.

A century after Kane's sketching trip, de Grandmaison reached the height of his artistic skill. Over more than two decades he would paint his most important and striking Indian portraits; they constitute a modern counterpart to the older panoramic cycles.

In these portraits by Nicholas de Grandmaison there is no diminution of vitality and freshness as often happens when a painter works in a dying tradition. Rather, they are portraits that grip the imagination. Many people have experienced reactions similar to my own when I saw a de Grandmaison portrait for the first time. It was hanging in a Calgary art dealer's window where I happened on it purely by chance. I know now that this first discovery was a very modest work when placed beside his more "regal" and ambitious portraits of chieftains. Yet this little painting had such brilliance of color, liveliness of air and crisp realism that the memory of its details has remained vivid throughout the intervening years.

The merit of his work lies in diverse qualities. His subjects are in themselves arresting individuals. As models for his most

important works, de Grandmaison chose men and women whose faces embodied features which he considered representative of a once-proud race. He found in them traits of superior beings who belonged among the world's aristocratic peoples and held their heads in haughty pride. Those whom he selected for his paintings are patriarchs who retain the physical features of the true Indian despite the fact that many of their tribal brothers have deteriorated through contact with Europeans. These figurative aspects he has the ability to catch with most effective precision. The dual focus on the outline of the head and on the details of the face supplies the essential ingredients in his pictures. He blocks in the silhouette of the skull, accentuates the high cheek bones and delineates the firm set of the chin; these combine in establishing aspects of his concept of the Indian.

De Grandmaison's draftsmanship is of such an order that he catches those overtones of character that mark a lifetime of understanding. These can be seen in the crow's-feet around the eyes and in the thoughtful lines in the brow. Equally, the tautness of the lips reflects a deep inner hurt at the loss of old ways with their traditional values. These psychological traits are wrapped in more obvious "Indian" clothing. His men wear badges of an ancient race such as their feather headdresses and pose in costumes painted with distinctive designs which differ from tribe to tribe. Some individuals wear masks adorned with carved heads of animals which belong to the religious world and their long-cherished beliefs. In these portrayals, de Grandmaison roots his paintings in that figurative art tradition which extends back to the age of Dürer and classical giants of the Renaissance. It is the art style in which he was trained at the English art school that he attended as a young man, but he sets his subject down with a deliberate and telling force which imparts life into every line of his documentary record of the faces of a people.

De Grandmaison chose to use the pastel medium; it provided him with opportunities to introduce subtle coloring into many passages. In addition, he uses color in a way that strikes a contemporary note. He echoes the discovery of the evocative moods that color conjures up when used in the manner of the Impressionists and Post-Impressionists. His heads are molded by many touches of pure hues which blend together visually and at the same time seduce the emotions. They vibrate in such a way that the heads which he paints lift themselves out of the static two-dimensional surface and are transformed into living individuals with blood pulsing through their veins.

There was in Nicholas de Grandmaison a fiercely independent spirit, an impulsive nature and a deep streak of romanticism which made him a man with grandly eccentric ways. His life had been such as to make him an ideal interpreter of the Indian; in his background were events that gave him a deeper empathy with the native peoples than many other artists were capable of feeling. De Grandmaison had been reared in the world of the Russian aristocracy and had then seen his own culture wiped out in a violent revolution. He was left a bereaved spirit who reached out and identified himself with the Indians who were themselves threatened with the loss of their traditional beliefs and culture. In his paintings he raises the Indian head in a gesture of challenge to a new and alien society. This seems to mirror a personal reflection of what had happened to his own people. De Grandmaison probably believed that he had found the modern counterpart of the "Noble" Indian, whom the eighteenth-century philosopher Jean-Jacques Rousseau had visualized and exalted in his romantic concepts and writings. Rousseau thought of them as lordly individuals who belonged to a higher plane than most because they had been molded and ennobled by an independent life lived in open spaces in close association with nature. The artist pictures the Indian in paintings that embody an inner strength, and the faces in his portraits gaze out at the world with a razor-sharp keenness and a confidence in their own values, defying the eradication of a proud and ancient race.

J. Russell Harper

NICHOLAS DE GRANDMAISON

The drum began a slow rhythmic beat, followed by the quavering falsetto voice of an Indian singer. Other voices joined in, but the singers were drowned out by the noisy brass bells of the prairie chicken dancers who were leading a small parade of Peigan Indians. Walking proudly among them was an elderly white man.

Nicholas de Grandmaison, after thirty years as an artist who had devoted his work to the Indians, was being honored by the Peigan tribe.

He sat cross-legged on a pile of Indian blankets and smoked the ceremonial red stone pipe. Charlie Crow Eagle, patriarch of the Peigans, took some red ocher from his paint bag, mixed it with fat in the palm of his hand, and applied it liberally to the artist's face. Then, with more careful strokes, he applied yellow ocher in horizontal lines across the eyes and mouth. Finally, the patriarch set the eagle feather headdress, the symbol of leadership, on de Grandmaison's head, and the assembled Indians gave the traditional war whoop.

Crow Eagle announced that their friend had been named *Enuk-sapop* — Little Plume — and that he was now an honorary chief of the tribe. De Grandmaison, who had once been part of the elite of imperial Russia, had just been accepted into one of the proudest and most respected tribes of the Canadian plains.

Nicholas Raffael de Grandmaison was born in southern Russia on 24 February 1892 to parents with a noble French and Russian background. His great-grandfather Jean de Grandmaison was born in Normandy, then orphaned during the French Revolution. When Catherine the Great offered to raise the children of aristocratic French families at imperial expense, the young Jean was sent to Russia and educated at a military academy, later serving as a colonel in the Russian army against Napoleon's forces in 1812. Thus began a military tradition among the de Grandmaisons. Jean's son Peter was a medical doctor with the army, and Peter's two sons, Raffael and Leonid, both were officers in the imperial army. It was expected that Raffael's son Nicholas would join the army when he came of age.

Nicholas de Grandmaison spent his earliest years in the town of Poltava where he grew up speaking French and Russian, since French was the language still spoken by the Russian elite. As a boy he showed an interest in art which he expressed by drawing pictures on the walls of his family home. In 1900 Nicholas's father, who was still in the army, died. His widowed mother, the former Lubov Varvarov, took the three children — Nicholas, Michal and Mary — to her parents' home in Obojan in the province of Kursk. Two years later the ten-year-old Nicholas was sent to Moscow to live with his Uncle Leonid, an army officer who was a member of Moscow society and a frequent visitor to the royal palace. In 1904 the boy was enrolled in a college dominated by Russia's ruling class and learned the ways of a gentleman, with lessons in music, art, languages and history. He graduated from the college at the age of nineteen and was then sent to a military academy, a training center for officers. There he learned very little about discipline, either for himself or the troops, and nothing about military tactics or the use of firepower.

Charlie Crow Eagle (right) inducts Nicholas de
Grandmaison as an honorary member of the
Peigan tribe, 1959.

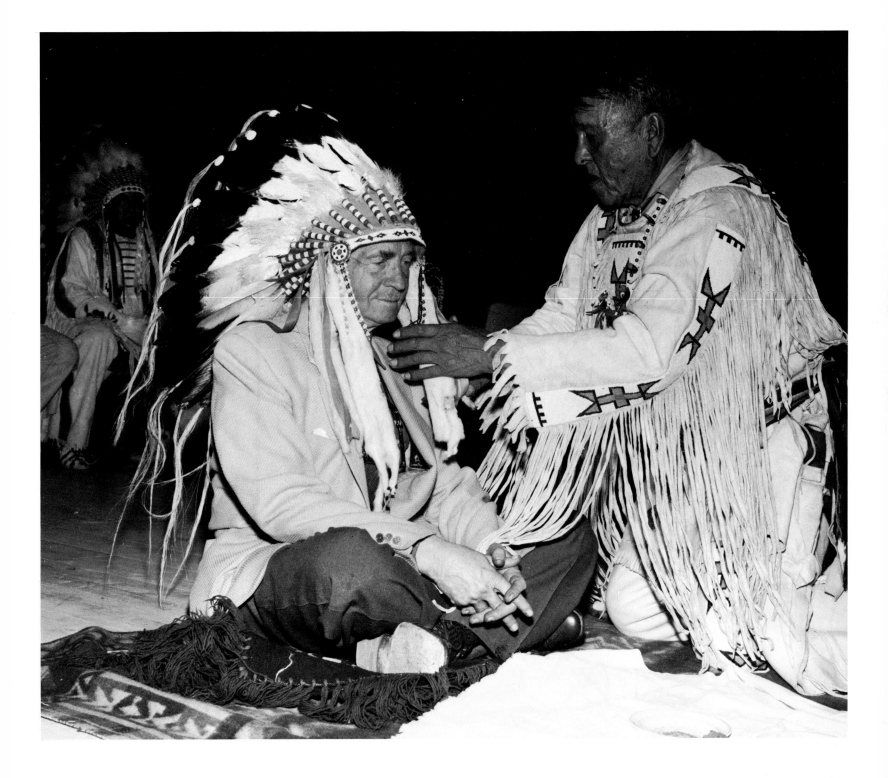

Instead, he dressed in his fine uniform, took his turn as a guard at the royal palace and, when possible, pursued his hobby of drawing.

After two years in the military academy de Grandmaison was commissioned as a sublieutenant in the Nevsky Regiment, the first infantry regiment of the imperial army. Near the end of July 1914, as war threatened Europe, the czar ordered a general mobilization of the army and navy, and very soon the young officer found himself fighting in a war against the German army. His military career, however, was short-lived, for he was among the first Russians captured just before the decisive battle of Tannenberg in August of that year.

De Grandmaison spent four years in a prisoner-of-war camp where he was interned with Allied officers from France, Great Britain and other countries. He learned a smattering of German and English during his years of confinement and turned to art as a diversion from the monotony of prison life. Although his military training had included the basics of drawing, particularly in cartography and topography, de Grandmaison was essentially an amateur who selected portraiture as his field because the prisoner-of-war camp offered few alternatives. In addition he was responding to the requests of fellow officers who wanted to sit for him, either to have a souvenir or to relieve their own boredom. On at least one occasion he painted a high-ranking German officer, a mutton-chopped Prussian wearing an Iron Cross at his neck. Usually he painted in oils but also made use of pastels, his selection probably being based upon the availability of art supplies.

When hostilities ended de Grandmaison rejoined the imperial army and served for a short time during the civil war in Russia; in 1919 he was sent to a Russian officers' training camp in Newmarket, England. A few months later when the Bolsheviks crushed the imperial armies, de Grandmaison found himself in a foreign land without a profession and without a homeland. Registered as an artist under the British Aliens Act, he sought out a number of British officers whom he had met in Europe at the end of the war.

At this time Nicholas de Grandmaison was a slim, wiry man with a military moustache, hair parted on the left side and dark sensuous eyes. He spoke English with a thick Russian accent, and his grace and aristocratic charm delighted the ladies.

It was the officers' wives, rather than the officers themselves, who opened their hearts and pocketbooks to the young artist, and of the four addresses he registered with the Aliens Board at different times, three were those of women friends — Miss Hilton and Mrs. Cox in Newmarket, and Miss Tarrant in South Hampstead. His most helpful friend was Lady Ivy Dundas whose husband had been an officer in the Royal Flying Corps and was a brother of the Marquess of Zetland. Lady Ivy took de Grandmaison to her estate, helped find painting commissions for him and, in 1921, arranged for the young Russian to study at the St. John's Wood School of Art in London.

"I do hope you will make lots of money, dear," she wrote to him there, "and I wish I could help you. Do work very hard so as you will not have to go to Russia."

The threat of being deported was a real one which stayed with de Grandmaison as long as he was in England. Although there was a great deal of sympathy for the refugees of the Bolshevik revolution, the finding of employment was a condition of the Aliens Act for those who intended to remain in England.

However, after leaving art school, de Grandmaison seemed to be content to stay in England as long as that country would keep him. He lived on or near the Dundas estate and garnered enough commissions to keep him occupied, but made no real attempt to establish himself, either in England or elsewhere. By 1923 the Dundases were becoming concerned about their Russian émigré and finally decided to do something about it. "Feeling a change of scene for Nicky might be refreshing for all concerned," recalled a friend, "they gave him ten or fifteen pounds and told him to put it 'on ze nose' of a horse they had named Pomme de Terre, which they were sure would win the Craven Cup race at Newmarket. It came in leading the field by lengths and paid substantial odds and while Nicky was in funds they suggested that Canada was a friendly country of great promise and opportunity."

Emigrating to Canada as a farm worker, de Grandmaison was sent to Manitou, Manitoba, where both he and the farmer found that the young Russian had no aptitude for agriculture. Late fall found him in Winnipeg, where he had a letter of introduction to two men who were fraternity brothers of a friend of the Dundases. With $100 of borrowed money, the artist arrived on the doorstep of the two men who "dusted him off, helped him to find lodgings, bought him meals to keep him from starving, and generally kept an eye on him from time to time."

A measure of de Grandmaison's charm was that the people he imposed upon usually became his lifelong friends, ready to use their influence to help whenever possible. Somehow his unorthodox ways, his courtly manners and his appealing Russian style of speech captivated those who came to know him. He enjoyed the help of friends all his life, his engaging personality taking him from one painting commission to another.

Sharing rooms with a couple of Russian immigrants he met in Winnipeg, he survived the winter. Then, with the help of friends, he got a job in the spring of 1924 at Brigdens of Winnipeg Ltd., one of the largest printing and engraving firms on the prairies. Long a haven for western artists, this firm published the *Grain Growers Guide* (a leading agricultural magazine) and numerous catalogues and periodicals. De Grandmaison's talents were directed into the routine of a black and white layout artist. At the same time he joined the Arts Club of Winnipeg and was soon seeking commissions for portraits.

Initially he painted mainly children's portraits and, with Winnipeg riding a wave of prosperity in the 1920s, found enough commissions to keep him busy. He had no problem painting children and proved to be patient but firm as he petted and cajoled them into sitting quietly while he quickly made his preliminary sketches. Yet children's portraits were not his forte, and as soon as he could he

abandoned this type of work entirely. By 1964 he was able to say, "I do not paint young people, for they have not lived enough or suffered enough to have interesting faces."

In the beginning he was prepared to execute pictures either in oils or pastels but, by 1925, he preferred to concentrate on the latter, as he believed that pastels provided a better medium to record the fine nuances of the soft and warm textures of the skin.

His first major adult commission came in 1926 when the Law Society of Manitoba asked him to produce oil portraits of Chief Justices MacDonald and Pendergast, Sheriff Inkster and Hugh John Macdonald (former premier of Manitoba and son of Canada's first prime minister). A year later he ventured into the field of illustrator art with a full-color painting on the cover of *Grain Growers Guide*. With his career blossoming, de Grandmaison began to dabble in the wheat market and soon was plunging all his money into the local grain exchange. In fact, gambling was always a passion of his life. He could be down to his last dollar but, if the urge struck him, he was ready to gamble it away, unmindful of tomorrow.

Like many other investors in Winnipeg, he was virtually wiped out by the stock market crash in 1929. Not only did he lose the money he had invested, but the orders for sittings dried up as quickly as the economy and the drought-stricken prairie fields. Before the crash de Grandmaison had decided to leave Brigdens to devote his full time to painting and to earn a living from portrait commissions. He now realized that he also needed portraits of general interest which could be sold to collectors.

In 1927 he had made a few exploratory field trips in search of subjects, but his major foray was in the spring of 1930 when he travelled to The Pas in northern Manitoba to paint portraits of trappers, prospectors, fur traders, Métis and Indians. When he returned, the *Winnipeg Evening Tribune* was eloquent about the results. "Sketches of this kind represent a portrait painter at his best," the critic observed. "He painted for sheer love of painting, and has to satisfy only himself." The collection was "the best work he has produced thus far."

By the end of the summer de Grandmaison had amassed a good collection of paintings and arranged for his first showing at Richardson's Gallery in Winnipeg. The public response to the exhibition was fair; however, with the depressed economy, no one seemed interested in buying. At first de Grandmaison was discouraged, but near the end of the show a wealthy Minneapolis businessman bought six Indian portraits, providing the artist with enough money to carry on his work.

The year 1930 proved to be a decisive one in de Grandmaison's career. His spring and summer trips gave him a chance to see the various types of people to be found in the hinterlands but, more important, they gave him a chance to discover the Indians. In Winnipeg he had seen native people on the streets, and his first cover illustration for *Grain Growers Guide* in 1927 depicted an Indian couple in a canoe, but he had no experience with Indians in their own habitat. Yet his exhibition had proven that Indian portraits were the only ones that would sell.

De Grandmaison decided that the Indians were perfect subjects for his pastels and oils. In his romantic mind these one-time nomads still retained an aura of independence and pride which he hoped to find reflected in their faces.

What he sought were "pure" Indians whose faces showed no strain of Scottish, French or other European heritage and he set out to find them in their own lands. He had concluded that the Indians of eastern Canada, who had been involved with Europeans for a longer period and had intermarried with them, no longer had "pure" features.

He became interested in the Plains Indians who lived west of Winnipeg and obtained a letter of introduction to W.M. Graham, commissioner of Indian affairs in Regina, Saskatchewan. Stopping in the Qu'Appelle Valley and File Hills in Saskatchewan, he was impressed by some of the people he met, particularly a Cree named The Walker, or *Pemota* (figure 5). Over the years de Grandmaison painted him several times and, perhaps because his was the first classic Indian face he saw, later named an art company after him. From there the artist went to the Blackfoot Reserve east of Calgary, Alberta, where he met the Indian agent George H. Gooderham. This was the beginning of a lifetime friendship between the eccentric artist and the courtly Gooderham. The agent suggested a number of Indians who might be suitable models and provided his own interpreter, Joe Calf Child, to accompany de Grandmaison. The artist continued west to Calgary, stopping at the Stoney and Sarcee reserves before going south to his meeting with the Blood Indians.

He had been told by an Indian Department employee that the Bloods had the largest reserve in Canada and that, with a population of more than two thousand people, they were much like their buffalo-hunting ancestors. When he arrived within the shadow of Alberta's Belly Buttes, which marked the entrance to their lands, his fondest hopes were realized. He was unconscious of the decrepit log shanties, the children in rags and the incredible poverty, but saw only the hawklike weather-beaten faces which to him typified the wild and untamed warrior of the plains.

His "discovery" was, however, based more on illusion than reality. In the piercing eyes and haughty demeanor of a man such as Longtime Squirrel (figure 14), de Grandmaison envisioned a warrior of old, capturing horses from an enemy camp, striking down a foe in battle and moving endlessly from campsite to campsite. In fact, Longtime Squirrel had been less than ten years old when his family settled on the Blood Reserve and, like most of the artist's subjects, life on the reserve was the only one he knew.

Comparing them with his own background as a member of the Russian ruling class, de Grandmaison saw the Plains Indians as the aristocrats of North America. And perhaps, as someone suggested, he saw "in these dark faces something very close, almost like an icon image, that he remembered from his childhood."

De Grandmaison was excited by his trip to the Blood Reserve and soon had a notebook full of the names of Indians he wanted to paint. In the years that followed, the Blood Reserve was his favorite place for painting, partly because the large population offered a wide

Nicholas de Grandmaison in 1943.

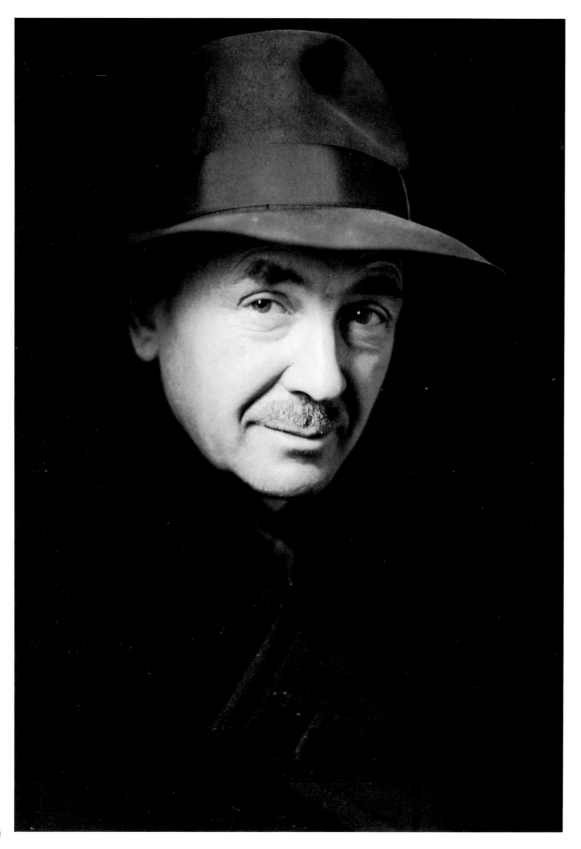

selection of models, and also because their lack of intermarriage with Europeans afforded him the "pure" Indian faces he sought.

By the time the trip was over, the artist had a portfolio full of paintings of Blood, Peigan, Stoney and Sarcee Indians. Back in Regina where he decided to stay for part of the winter, he made trips north to the area around Saskatoon to paint the Crees and Assiniboines who lived there. He was now convinced that he had discovered his goal in life: he wanted to paint Indians.

De Grandmaison was only one of several artists who had gone among the Plains Indians over the years with a similar purpose. In the nineteenth century there had been George Catlin, Paul Kane, Karl Bodmer and Gustavus Sohon. In the Qu'appelle Valley, James Henderson had begun painting Cree portraits in 1916 and later included some Blackfoot Indians among his works.

Ten years before de Grandmaison arrived in Alberta, a New York artist named W. Langdon Kihn had been painting portraits of the Stoney, Blackfoot and Cree Indians, while in the late 1920s, New York artist Winhold Reiss had established a summer school in Glacier National Park, Montana, using Peigan and Blood Indians as models. Reiss's own portraits of Indians graced the calendars of the Great Northern Railway for many years during the same time that de Grandmaison was painting — often using the same models.

Undoubtedly de Grandmaison knew of these other artists, particularly Kihn, Reiss and Henderson, but he approached his work with a sense of purpose, as if he alone had undertaken the daunting task for the sake of history and humanity. And, in his mind, the responsibility was great and ever present.

As a result of this decision, de Grandmaison established a pattern which he followed scrupulously during his career. When he needed money he sought commissions, either of white children or businessmen; but at other times, particularly in the summers, he devoted his attention to Indians. Some of the Indian portraits he sold, but others he refused to part with. And wherever he travelled he carried a tightly bound portfolio of some of his finest works. He seemed almost afraid to leave them behind in case they might disappear.

From the beginning, de Grandmaison's methods of doing business were unorthodox but effective. He kept no records or receipts but carried with him a bundle of dog-eared notebooks in which he wrote the names of possible contacts, orders for works, names of Indian models and other related items. Mostly, however, the books were filled with the names and addresses of businessmen from one end of Canada to the other. It seemed like a jumble of notes, but he could always pick out the one he needed; whenever he arrived in a city or town, a list of contacts was at his fingertips. In this way he was able to maintain an adequate if irregular business, even during the depths of the Depression.

And, from the first, he did not sell his services cheaply. He had no set price, but commissions ranged from $500 to $1500 even in the depressed 1930s. At that time he was getting a better price for his works than artists in the distinguished Group of Seven, whose

distinctive school of landscape painting was dominating the Canadian art scene. This was a point which pleased de Grandmaison. He charged what he thought his client would pay, but in a burst of impulsive generosity he would sometimes give away a painting for nothing.

Because of Calgary's proximity to the Blood, Peigan, Stoney and Blackfoot Indians, de Grandmaison decided to make that city his home, though his contacts in Winnipeg and Regina often had him travelling to those points to fulfil commissions. He was virtually a nomad for the first half of the 1930s. Even his marriage late in 1931 did not lessen the frequency of his trips.

His beautiful bride Sophia (Sonia) Orest Dournovo was born in Russia where her parents had known the de Grandmaison family. At the outbreak of the revolution they had escaped via China and eventually reached Canada. Sonia's father, Colonel O.L. Dournovo, had been responsible for bringing a large number of Russian immigrants to western Canada. Sonia was a sensitive sculptor in her own right and she continued to produce commissioned works after their marriage.

Combining a honeymoon with business, the de Grandmaisons went to Spokane, Washington, where he undertook a portrait commission. When they arrived back in Calgary, he learned that his artist friend A.C. Leighton was ill and, therefore, unable to conduct his classes at the Provincial Institute of Technology and Art. De Grandmaison was asked to share responsibility for his classes, teaching art two afternoons and two evenings a week during the winter of 1931-32. He did not particularly like the confining nature of the routine but enjoyed the students and the assurance of an income during the first winter of his marriage. This experience led him to examine more critically his own work and style of painting. As a result, he decided to give up oils, except for certain commissions, and to concentrate on pastels. This was partly because of the simplicity of using that medium while visiting Indian reserves, and also because it did not require the more demanding studio conditions and lighting necessary for working in oils.

When doing a portrait, de Grandmaison preferred to bring an Indian into his studio, either a makeshift one in a hotel or in his van, where he had control of the lighting. If it was in a hotel room, he fastened spotlights to the curtain rods and set up reflectors, sometimes making use of natural light from the window. He positioned his model with great care, convinced that each subject required a particular setting to give the kind of picture he wanted.

Throughout the 1930s and 1940s de Grandmaison perfected his style, doing less and less actual drawing in the face but creating the facial structure through the skillful use of color. As he became more assured his style became looser and he applied more and varied colors to the paper. Pinks, purples and dark blues became important elements in developing the facial form, with ochers and turquoise shades creating strong shadows. For a people who were considered to be brown in complexion, he used that color sparingly in creating the

Indian faces.

Through experimentation he devised a technique whereby he used the juxtaposition of color strokes to achieve a heightened effect in his pastel portraits. To do this he had to study each model's face to discern any nuances which could best be expressed by the selective use of color. The backgrounds and many of the costumes became abstract splashes so as not to distract the viewer from the detailed features of the face. In fact, when the faces in a number of his works are covered (e.g., figures 15 and 16) and only the costume examined, they result in interesting works of abstract art. Yet de Grandmaison heatedly rejected the idea of nonliteral art. "Lines merely reflect nothingness," he snorted. "Abstract art! You can have it."

He used a special pastel paper which he imported from France; it had a rough sandpaper finish on one side and was smooth on the other. His pastels were Grumbachers which he dumped helter-skelter into a large cigar box or cookie tin. From it, he always seemed to be able to pick out the exact shade that he wanted.

When the paper was in place on the easel, he used a charcoal stick to lay out the anatomy, usually taking about half an hour to sketch in the face: eyes, nose and hollows in the cheeks. With this simple guide, he shifted to pastels, beginning with the flesh tones and then doing the eyes and mouth. The eyes, in particular, received his most critical attention and he often spent more time on them than on any other part of the picture. The hair, costume and background, which came last, were created with a few quick lines and shades. In a few instances, when de Grandmaison was impressed with a person's costume (figure 29), he might spend more time on the details but did nothing to distract from the face.

If there were facets of the model which the artist did not like, he had no hesitation in changing them. A man with thin graying braids might end up with thick black ones, while someone with no braids at all would have them added. If something about the mouth bothered him, he would make subtle changes which improved the painting but did not alter the appearance of his model. People like Walking Buffalo (figure 40) and Shot Both Sides (figure 19) who were considered somewhat ugly had the size of their lips reduced and their faces transformed into pleasant but recognizable adaptions of their real features.

As soon as he had finished teaching classes in Calgary in the spring of 1932, the de Grandmaisons set out on their travels, moving from hotel to hotel — the Palliser in Calgary, the Hotel Saskatchewan in Regina, the Royal Alexandra in Winnipeg — each time setting up a studio and gallery in their room. The resulting publicity sold a few Indian portraits and garnered more addresses for his notebook. Soon, institutions like the University of Saskatchewan began to commission works and to buy his Indian portraits.

When their first child, Orest Nicholas (Rick), was born late in 1932, the family continued its wandering life. Not until the couple were expecting their second child, Tamara, in 1936 did they settle in a house in Calgary. Other children born to them were Nicholas, Jr., in 1938, Sonia in 1946 and Lou-Sandra in 1951. But even his growing family could not keep the artist at home, and soon he acquired a

trailer which he turned into a house-studio that he could sometimes take out to the reserves. In later years this was replaced by a mobile home built to his specifications.

During this period de Grandmaison developed a reputation for being an eccentric nomad who would show up at a friend's house unexpectedly at any hour. "One time," recalled a friend in Lethbridge, Alberta, "we had invited some twenty guests to dinner and a few hours before their arrival came a telephone call from Fort Macleod. It was Nick on the line. Could he come to us for overnight and, please, would Ethel prepare for him some boiled chicken and dumplings?" Although they were having a dinner party, de Grandmaison was welcomed and assured that he would be served boiled chicken and dumplings instead of the roast beef that was planned for dinner. When the guests, de Grandmaison included, were seated at table, the special dish was brought from the kitchen for him. He suddenly commented, "I'm not hungry. I don't want any chicken and dumplings!"

The hostess jumped to her feet, sparks flying, and cried, "Damn you, Nicky Grandmaison, you'll eat boiled chicken and dumplings if I have to stuff it down your gullet." He ate the chicken and dumplings.

De Grandmaison was also famous for his impulsive behavior. One time he had reservations on the train from Winnipeg to Calgary, but when he arrived at the station in minus-forty-degrees-Celsius weather, it had already left. "When does the next train leave?" he asked the ticket agent.

"There is another train leaving in two hours, Mr. de Grandmaison, but unfortunately it goes to Toronto, while you are Calgary bound."

"Then I'll go to Toronto. Let me have a ticket."

With few exceptions de Grandmaison was not really interested in his Indian subjects as individuals. He often was insensitive to their feelings and would have been surprised if told that he had insulted one of his models. He persisted in using terms such as "squaw," "papoose," and "brave," even though these were anathema to most Indians. On one occasion in the 1950s he went to a farm on the Blood Reserve where he found a large two-storey dwelling containing all the conveniences of the city. The woman of the house was educated, spoke perfect English and was well travelled; but as soon as the artist saw her, he exclaimed that she had a good squaw's face and asked for permission to paint her. The woman did not know whether to be flattered or insulted but, sharing the common belief that he was a bit crazy, she agreed to sit. Anyone else would have been ordered out of her house.

De Grandmaison got away with this outrageous behavior because the Indians believed that he was slightly mad. Among the Plains Indians, insane people were thought to be inhabited by spirits who controlled their actions and were, therefore, treated with consideration, partly because they were not responsible but also because no one wished to antagonize the spirits. De Grandmaison was considered to be more strange than mad, but eccentric enough

De Grandmaison visited the Crees in the File Hills of Saskatchewan during a winter celebration in the 1940s. The house in the background belonged to his favorite model, *Pemota,* or The Walker (figure 5).

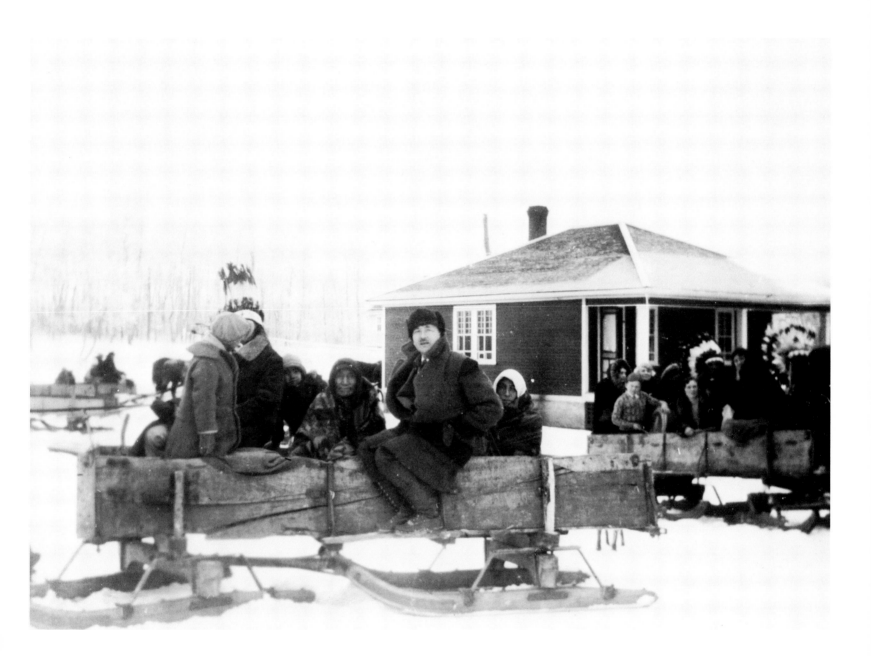

that his behavior rarely caused anger or resentment. He could barge into a tepee or house and unknowingly interrupt some important business — yet not only was he accepted but most Indians found it hard not to like him.

At a time when the only white people to go on a reserve were missionaries and Indian Department employees, de Grandmaison was a refreshing change. Friendly, casual, down-to-earth and totally uninhibited by his strange surroundings, he was so obviously completely at ease that he soon made others feel the same way. There is no doubt that he meant it when he said he loved the Indian people, and they, in turn, responded to his warmth and candor.

Interestingly, de Grandmaison often made no effort to find out whom he was painting. If it was a woman, he simply inscribed the picture *Squaw,* and the name of the tribe; if it was a child it was inevitably *Papoose.* Some of the men he identified, but probably in order to make the painting more salable or to have the information in case he wished to come back. Some of his models, like Riding at the Door (figures 33, 44, 63) and Wolf Tail (figures 1, 52, 55) were painted several times. Each portrait was done at a new sitting, and if several years had elapsed, the age differences are immediately evident.

Only later did the artist become conscious of the historical significance of the names of his subjects. Today, when his paintings are taken to the reserves for identification, so faithful are the likenesses that the sight of a departed relative can bring tears to the eyes of the viewer. "Ki-ai-yowww," a woman might exclaim softly, "it's just like him."

Sometimes an Indian might gaze for a long time at a picture of someone who was supposed to be his or her grandfather or uncle. Finally, the person would nod hesitantly and say, "Ah, it's him all right, but he looks kinda different. He's a lot handsomer than I remember him."

During the years de Grandmaison was building his reputation as an artist, he was widely known as a character. He was careless about his appearance, whether in the home of an eastern industrialist or an Indian tepee. He seemed to think that the sole function of clothes was to cover his body, and no one should be concerned if they were spotted with pastel dust or stained with paint.

Similarly, he had no concept of how his appearance might be perceived by others. Once when he entered the lobby of the Palliser Hotel and saw an attractive girl who was a complete stranger, he grandly took her by the arm. "You have the most beautiful eyes," he said effusively in his thick Russian acccent. "You must be Irish. Who are your parents?"

All the girl could see was an unkempt middle-aged foreigner who was accosting her in a hotel. De Grandmaison could not understand her embarrassment or why she fled from his sight. He had no idea that he had done anything wrong, for he was not conscious of the social conventions and strictures that apply in normal society.

The artist could also be moody and unpredictable. Some

people who saw him when he was angry or depressed assumed that he was a sullen man, but those who knew him well realized that he could snap out of a bad mood as easily as he slipped into it. Then he became a witty and engaging conversationalist who kept everyone entertained with his stories and personal philosphies.

Joe Clark, former prime minister of Canada, recalled de Grandmaison visiting his parents' home when he was a child. "Guy Weadick and Nick Grandmaison arrived at our house in High River," he said, "unannounced but welcome, at five minutes to supper time. I was sent to bed about an hour later, but crept down to listen to the rich conversation that lasted well into the night."

Early in his career de Grandmaison had a few artist friends, notably Gus Kenderdine, A.C. Leighton, Max Bates, L.L. Fitzgerald and Walter Phillips. Later, as he became more engrossed in his Indian paintings, he tended to drift away from the art community. In 1935 two of his portraits of white children were included in an exhibition organized by the Royal Canadian Academy, and seven years later he was elected an associate member of that elite body. Yet he did not not become active in the RCA nor was he interested in exhibiting in commercial galleries. In fact, he became violently opposed to commercial galleries, refusing numerous offers by them to handle his work. He was so hostile that on one occasion when he had to meet someone in a Toronto gallery he donned a coat, slouch hat and dark glasses so that no one would recognize him.

The result of his antipathy to the art community, its galleries and exhibitions was that de Grandmaison became a commercially successful artist who was virtually unknown in the art world. Many art critics considered him to be nothing more than a portrait painter who produced works akin to calendar art. Others saw him as a man with a singular talent for painting Indians, businessmen and the children of the rich.

In 1939 the de Grandmaison family moved to Banff and rented a cottage belonging to the family of Peter Lougheed, the premier of Alberta. They lived there for seven years, until the artist could build his own house on Cave Avenue, his first home with a studio. The Stoney Reserve was not far from Banff, and the family established personal relationships with some of the Indians there, collecting clothes for the indigent ones. White Headed Eagle (figure 64) was a frequent visitor, sometimes doing work around the place but often just dropping in for lunch and a chat.

But de Grandmaison spent more time away than he did at home. Whenever business took him to eastern Canada, he rushed back at the first opportunity and headed out to one of the reserves. He was happiest when among the Indians, painting or just visiting.

During these years in Banff, de Grandmaison also maintained a room at the Palliser Hotel in Calgary, where a periodic visitor was Big Kidney (figure 16) of the Blackfoot tribe. Sometimes in town for several days on a drinking spree, Big Kidney would plant himself on the front steps of the Palliser when he needed money and would not move until de Grandmaison arrived. Then he would meekly follow the artist upstairs, sit for him and receive his fee.

Nicholas de Grandmaison at his Banff studio in
the 1950s.

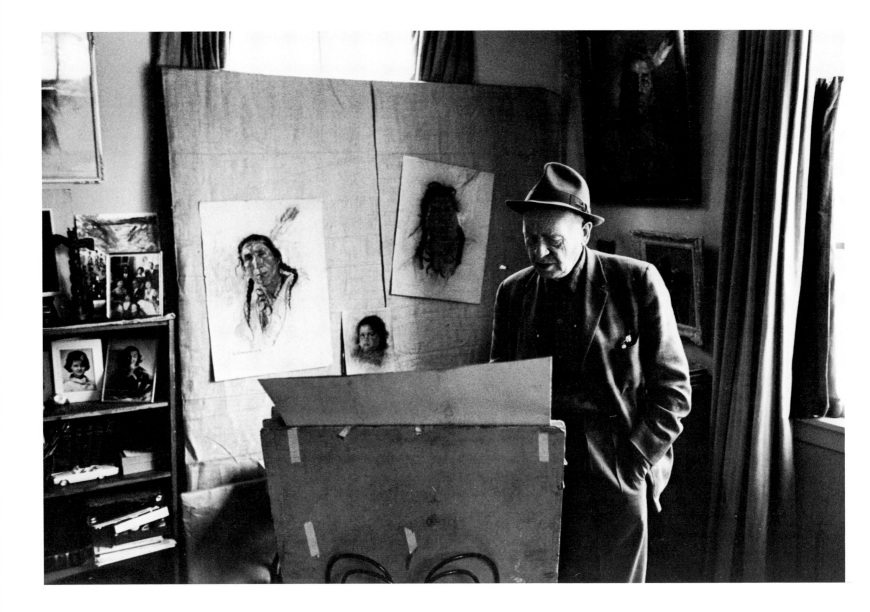

Technically, de Grandmaison reached the apex of his career in the late 1940s when his style had been perfected and he was still a healthy and vigorous man.

By then, he had developed the idea of creating his own collection of some of his finest works. Perhaps this had been at the back of his mind for a number of years, because he had saved paintings which dated back to his first extensive field trip in 1930. When a reporter noticed that the artist would not part with many of these works, he asked the reason. "If I sold them," de Grandmaison replied, "I would only have money and I could not keep it, but the drawings I can keep. They are my life." These paintings grew in number until he had a thick portfolio which he carried with him whenever he travelled. They were the ones he used in small exhibitions to attract patrons and commissions, as well as to gain publicity in the press. As he grew older, his "collection" became his monument to his art and his bequest to his family. While the collection included some of his finest works from various periods of time, it also contained some which were inferior in style and execution. This may have been another of the idiosyncracies which were part of de Grandmaison's complex character, or it may have reflected a special regard he felt for a subject.

Although two or three major corporations looked into the possibility of acquiring the collection, it was not until shortly after the artist's death that the de Grandmaison family sold the portraits to the Bank of Montreal in 1978.

In the late 1940s de Grandmaison became more and more conscious of his role in preserving a record of the Indians. However, with the exception of a couple of trips to British Columbia, Montana and Spokane, Washington, his entire career had been spent on the Canadian prairies. It occurred to him that perhaps he was being too narrow. If he could expand his portfolio to include Indians in the United States, his work would become more international in scope.

In 1950, after his old friend Guy Weadick had moved to California, de Grandmaison approached him about the idea of working in the United States. Weadick, who was an entrepreneur and the originator of the Calgary Stampede, was enthusiastic. He laid plans for the artist to paint in the northern states during the summer, then move to the Southwest as cold weather approached. He was prepared to act as de Grandmaison's agent, to line up exhibitions and to arrange for publicity. After several months of optimistic correspondence, Weadick finally dropped the matter. Try as he might, he could never get de Grandmaison to commit himself to a business agreement, nor would the artist agree to make his Canadian collection available for the American market. As Weadick observed, "he is a fine artist in his line but a damn poor businessman."

But the idea for an American collection had grown in the artist's mind, so late in 1951 he set out with his son Rick to paint Sioux Indians who had been involved in the battle of the Little Bighorn against General Custer. Upon arrival at the Pine Ridge Reservation in North Dakota, he learned that two of the last three

survivors had died a short time earlier, and the only man left was High Eagle. Although he had been photographed, no one had ever painted High Eagle, partly because he lived in a remote corner of the reservation and also because he was hostile to and suspicious of Americans. The old patriarch had to be convinced that de Grandmaison was not an American before he would agree to sit. Two months after the portrait was finished, High Eagle was killed in a traffic accident.

Heartened by the success of his meeting with the Sioux, de Grandmaison travelled to the area around Phoenix, Arizona, in the following year. He stayed there for several months to paint the Apache, Pima and other Indians in the region. Upon his return to Canada he had the beginnings of an "American collection," but his means for promoting it had died with the collapse of the deal with Weadick.

In 1956 Father Athol Murray, head of Notre Dame College in Wilcox, Saskatchewan, decided that the walls of his buildings should be lined with portraits of great living Canadians. De Grandmaison was commissioned to produce one painting, then two, and finally a flood of them, so that by the time the project was finished some twenty portraits graced the walls of the college. The choices reflected the priest's own interests in politics and sports, including Prime Minister John Diefenbaker, Saskatchewan Premier Tommy Douglas, and hockey players Lester Patrick, Merv "Red" Dutton and Jean Beliveau. The Notre Dame portraits form the largest single collection of de Grandmaison's works on non-Indian subjects and, next to the Bank of Montreal collection, the largest anywhere. The significance of the subjects of these portraits also enhanced de Grandmaison's reputation as an artist of national stature, as had his other commissions of politicians like Prime Minister R.B. Bennett, federal cabinet minister The Honorable C.D. Howe, Alberta Premier William Aberhart and Sir Frederick Haultain, chief justice of the supreme court of Saskatchewan and premier of the North-West Territories.

In spite of all this work de Grandmaison had not given up his ideas for an American exhibition, and in 1958 three old friends in the oil business in Calgary decided it would be a good business venture. Together with lawyer Webster Macdonald, the trio — Max Bell, Frank McMahon and Wilder Ripley — joined with the artist to form a company called The Last Arrow Limited. Their first act was to have de Grandmaison produce three pastels specifically for making high quality reproductions. Printed in Montreal, these were entitled *Cold Weather, Starlight* and *Blackfoot Brave*. Then, to help promote the sale of the prints, the company organized a series of exhibitions, drawing upon twenty-five of the finest works in de Grandmaison's personal collection.

The tour opened at the Los Angeles County Museum, moved to the California Academy of Sciences in San Francisco, then to Grove City in Orange County and finished at the Morrison Planetarium in San Francisco. Throughout the circuit, the exhibition received good press coverage and reviews.

The paintings went on a tour of eastern Canada in 1960. The company flooded the newspapers with press releases, garnered an article in *Time* magazine and generally promoted the show on a national basis. The results, however, were disappointing. The tour opened in Toronto, moved to the McCord Museum in Montreal and closed at Keith Hall in Halifax, Nova Scotia, without having had a show in a major gallery in Canada.

De Grandmaison was not surprised, for he was convinced that the Canadian art community had become so dominated by devotees of abstract art that his works would have been laughed right out of the average gallery. After all his years of ignoring the art community, de Grandmaison was ready to join it but found that now its doors were closed to him.

The basic purpose of the tours, of course, had been to promote de Grandmaison's art and the sale of his prints, but once more he proved to be as difficult to deal with as Weadick had found a decade earlier. The experience became increasingly frustrating for the backers of The Last Arrow Limited, and after several months the project was abandoned.

By this time there was a noticeable decline in the quality of de Grandmaison's work. He observed it himself in 1965, commenting, "Thank God I still manage to do my work which is getting spotty at times." So it was fitting that honors began coming to him when his best years were behind. The first and most important to him occurred in 1959 when he was inducted as an honorary member of the Peigan tribe. De Grandmaison was touched by the ceremony; to him, it was the climax of years of work and devotion to the Indians of western Canada.

Then, in 1972, de Grandmaison was awarded the Order of Canada, a move supported by Alberta Premier Peter Lougheed who announced to *Maclean's* magazine that de Grandmaison was his favorite artist of all time. In 1976 de Grandmaison was recognized in his own province when he was given an honorary doctorate by the University of Calgary for his work as an artist among the Indians of western Canada.

But perhaps the crowning touch to his long and colorful career occurred just four months before his death, when the Peter Whyte Gallery in Banff featured the "de Grandmaison Family Exhibition." It was tangible evidence that the doughty old Russian had instilled in his family a love for art which was evident to all visitors to the gallery. His wife, Sonia, was a sculptor who had produced a number of commissioned works; Rick had studied at the Banff School of Fine Arts and Chelsea School in London, then painted in Europe before launching a successful career in Canada; Tamara Scholermann had studied in London and travelled in Latin America before becoming a portrait artist like her father; Nicholas, Jr. had studied architecture in Winnipeg and went on to have a successful career in that field; Sonia Szabados had attended universities in Vancouver and Calgary, then operated art galleries in Edmonton and Calgary before becoming an art broker; and Lou-Sandra Ferrari, the youngest, had developed her art in working with stained glass. If de Grandmaison's Indian

paintings were a legacy to Canadians, his artistic family was surely another.

Nicholas de Grandmaison died in Calgary on 23 March 1978, just two months after the family show closed in Banff. After services in the Russian Orthodox All Saints Church in Calgary, his body was taken to the Peigan Reserve, where Charlie Crow Eagle recited the last prayers in Blackfoot before the casket of Little Plume was interred in the cemetery on the reserve.

When informed of the death of de Grandmaison, Peigan elder Albert Yellowhorn recalled his first meeting with the artist in the 1930s. "He came on the reserve to do a picture of my father. He liked the Indian people and was well liked by the old timers. They accepted him. When I heard that he was being buried in the Indian cemetery at Brocket, where he was made an honorary chief, I thought it was a great gesture of friendship."

Nicholas de Grandmaison had devoted his life to the purpose of recording the faces of the Plains Indians of Canada. He had sought them out in their cabins, tents and tepees, worked under adverse conditions, but maintained a constant sense of purpose. To some people he was an eccentric, but to himself the measure of his life was in his art, not his personality. In portraits which are rich and colorful, he created images that fulfilled his own romantic expectations. And in the end, when he chose the Peigan Reserve as his burial place, he showed that in death as in life, he wanted to be with the Indians.

THE INDIANS OF WESTERN CANADA

For centuries the Plains Indians of western Canada had been proud and independent warriors and hunters who lived on the immense herds of buffalo that roamed the land. In the summer they killed the huge beasts singly from horseback and in the autumn stampeded herds of them off cliffs to obtain a winter supply of food. The Plains Indians based their entire way of life on the buffalo — its meat was their main source of food and its hide was used to make tepees and clothing — but the large-scale settlement of the west and the slaughter of the last of the buffalo in 1881 forced them to settle upon reserves and to accept the handouts of beef and flour that the government gave to them. In a matter of months the masters of the plains had been reduced to ragged mendicants whose existence depended on the benevolence of the white man.

When Nicholas de Grandmaison made his first painting tour of the prairies in 1930, the Plains Indians were generally a depressed and indigent people who had suffered neglect and privation for half a century. With a sense of urgency the artist dedicated himself to recording the faces of the Indians. "All the sorrow, oppression and history of their race is indelibly written on their faces," he said. "I must work quickly if I am to capture this on canvas before the race dies out or it commingles with that of the white man." In fact, the "sorrow" and "oppression" were often the result of malnutrition caused by spending a lifetime on a reserve where employment opportunities did not exist and the government food rations were the only means of survival.

The Indians whom de Grandmaison preferred to paint belonged to tribes that lived in southern Alberta and Saskatchewan. The Blood, Blackfoot and Peigan tribes which formed the Blackfoot nation ruled a vast area of the plains from the Red Deer River to the Missouri River, and from the Rocky Mountains to the present Alberta-Saskatchewan border. The members of the nation were at war with all the tribes around them — the Cree, Assiniboine, Kootenay, Crow and Sioux — helped by their allies, the Sarcees, a small tribe of tough fighters.

In the foothills of the Rocky Mountains lived the Stoneys, who were related to the Assiniboines (or "stone people") of southern Saskatchewan. The Bearspaw band of the Stoney tribe lived on the prairies, while the Chiniki band preferred the security and seclusion of the mountains and foothills, though they did venture onto the plains to hunt buffalo. The Goodstoney band was a forest people who hunted moose, deer and elk, as well as bighorn sheep and goats in the mountains. All three bands looked upon the Blackfoot and Kootenay as enemies.

The Crees were scattered over a large portion of western Canada. The Plains Cree lived on the prairies, and the Woodland Crees hunted in the forest. From their camps on the plains of Saskatchewan, Cree and Assiniboine war parties often set out on raids against the Blackfoot and Sioux nations.

A young man often went to war when he was fourteen or fifteen, travelling on foot with a party of seasoned veterans as they sought the herds of a hostile camp. To take horses from an enemy

Duck Chief and his family, Blackfoot Indians.

herd was a feat of skill and bravery, but the real test of a warrior was to creep quietly into an enemy camp and take a prized buffalo-running horse. A buffalo runner was used only for hunting and was so valuable that the owner sometimes tied it to a line which he slipped over his wrist while he slept in his tepee. If the raider could cut the horse free and steal it away from the camp without being discovered, he had performed a feat daring enough to recount at the next Sun Dance or record in a pictograph on his buffalo robe.

In some ways the Blackfoot were militaristic, with a complex system of warrior societies, such as the Horn, Pigeons or All Brave Dogs. The men of the Horn Society, for example, were about the same age and, in war, were willing to risk their lives for each other. At home, the society might be called upon to police the camp, or to guard it while it was on the move or to supervise the buffalo hunt. Yet these same societies were fraternal groups which also brought members together for ceremonies and feasts; women were allowed to participate in these, though they were not full members. A Horn Society leader might sponsor a feast, during which its holy bundles were opened and rituals performed to help a person who was ill. Medicine bundles were important to the ceremonies of prairie tribes, as each bundle consisted of the paint, incense and objects needed to perform a particular ritual. Some contained pipes which were smoked to bring good luck and good health. In fact, just about any object with a religious significance could be found in a medicine bundle.

Every tribe was divided into small family groups, or bands, each with its own leader who was a man chosen for his wisdom and bravery. The election was entirely democratic and, if a chief proved to be ineffectual, his followers simply abandoned him and chose a new one. Most chiefs, however, were the sons or nephews of previous chiefs and had learned how to lead wisely and well. As these men grew older, and lines became etched into their faces by the parching winds of summer and the bitter cold of winter, they became respected patriarchs of the tribe. All the prairie tribes venerated their elders and holy men, turning to them for guidance and listening to their counsels.

The holy men, like the chiefs, were leading figures in the camps. They often came to their calling because of visions or dreams and, through the teachings of older shamans, gradually learned the rituals and songs necessary to cure the sick, keep away evil spirits and bring good fortune to the tribe. Usually the inside of a holy man's tepee was lined with medicine bundles and other sacred objects which older shamans had passed on to him or which he himself had made because of a vision.

The Sun Dance, an annual religious festival, is deeply rooted in the mythology of all the Plains Indians, and each tribe had its own rituals and symbols for it. In Blackfoot mythology a woman married the morning star and, when she returned to earth, brought the Sun Dance ceremony with her. Held in midsummer, the Sun Dance consisted of a complex series of rituals based on the teachings of morning star woman. To hold the festival, a woman who was a

faithful wife and was respected in the camp had to make a public vow to sponsor the event. During most of the Sun Dance she remained in seclusion, fasting and praying for the success of the events, but came out to bless the building of the Sun Dance lodge. Through songs, prayers and dances, the people reaffirmed their faith in the power of the Sun Spirit.

The end of the nomadic free life of the Plains Indians was signalled by the signing of treaties between various tribes and the Canadian government. As a result of Treaty Number 4 signed in 1874 and Treaty Number 6 signed in 1876, the Plains Crees settled on a number of small reserves in the three prairie provinces of Manitoba, Saskatchewan and Alberta, sometimes intermingling with their woodland relatives and Ojibwa allies. In the reserves near Edmonton and Battleford there was considerable mixing of plains and woodland people, but in the reserves in the Qu'Appelle area were Indians who had known only the buffalo culture. Here, Nicholas de Grandmaison was most successful in finding pure-blooded models from the Crees.

In Treaty Number 7 signed in 1877, the chiefs of the Blackfoot, Blood, Peigan, Sarcee and Stoney tribes of Alberta promised to end their wars. The Canadian government took the tribes' vast hunting grounds in exchange for reserves of land allotted on the basis of five people per square mile and also promised to provide the Indians with medical, welfare and educational aid.

The Blackfoot chose a reserve about sixty miles east of Calgary on the main line of the Canadian Pacific Railway, while the Bloods had the largest reserve in Canada at a location southwest of Lethbridge. The Peigans were near Pincher Creek, adjacent to the Crow's Nest Pass, while the Sarcees settled on three townships on the western outskirts of Calgary. The Stoneys also selected a large reserve west of Calgary, with a few settling farther north at the Kootenay Plains and west of Edmonton.

Originally the government had hoped that the Indians would adapt to farming and become self-sufficient within a decade; but fifty years later, when de Grandmaison met them, few had made the transition and those who had were suffering from the Depression as much as white farmers.

The reserves were dotted with tiny cottonwood or pine cabins that were chinked with mud and had tiny sealed windows, though in summer tepees still served as the favorite shelter. There was no electricity on the reserves; cottonwood logs, piled tepee-fashion, were the only source of fuel for heating and cooking. Cast-iron pumps signified the presence of wells for water. Among the Crees of Saskatchewan and northern Alberta, mud ovens provided heat, while farther west the people clustered around cast-iron stoves. Missionaries — predominantly Roman Catholic, Anglican and United Church — were constantly pleading for bales of clothing from city parishes and eastern Canada so that they could be given to the old and infirm. Tuberculosis was running rampant, eye diseases were common because of the smoky cabins, and the infant mortality rate was shockingly high.

A transfer of ownership of a medicine pipe taking
place during a Blackfoot Sun Dance ceremony in
the 1920s.

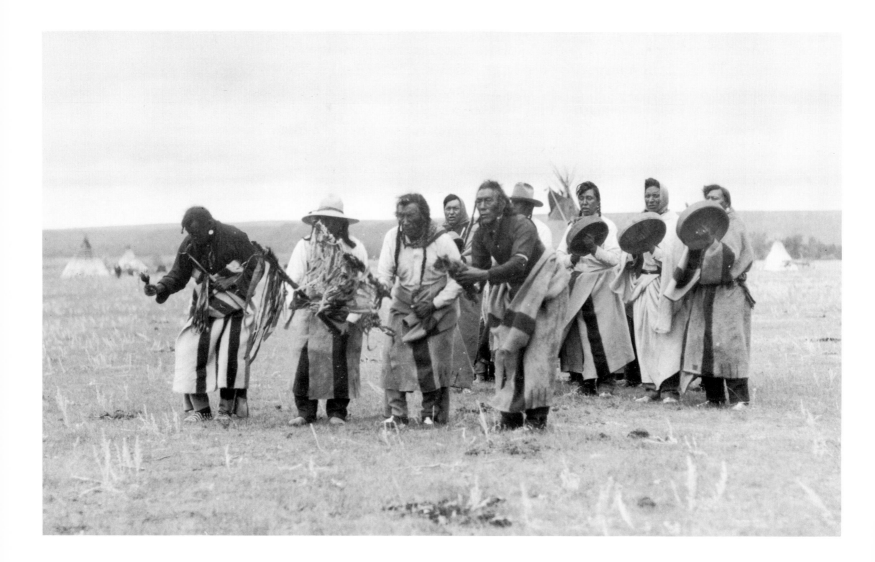

The Peigan Reserve at Brocket, Alberta, was typical of those visited by Nicholas de Grandmaison during the early 1930s. After he left Fort Macleod he would notice that the cultivated fields and frame houses of white farmers quickly gave way to the prairie grass and cabins of the reserve, which looked like a patch of original prairie preserved in the middle of a farming countryside.

In Brocket, de Grandmaison would stop at the neat frame buildings of the government agency to get a permit to go onto the reserve and an interpreter to accompany him. Along the town's dirt street by the agency were the other signs of white occupancy — stores, Royal Canadian Mounted Police office, grain elevators — while off in the distance were the large, brick residential schools of the Anglicans and Catholics. Close to the nearby river, cabins were scattered through the trees. There was usually a motley pack of dogs, all sizes, colors and breeds, as well as two or three children playing in the grass, the youngest being naked if it was a warm summer day.

Although some Indians, particularly women, were shy, they were usually hospitable and would invite de Grandmaison to enter a cabin. The artist would sit at the kitchen table and be served a mug of hot, black tea. The mixture of smells in the house was not unpleasant: smoke from the fire, the sharp aroma of tanned animal skins and some meat boiling in a pot on the stove. There was very little furniture, though there might be a religious picture on the wall.

Of course, not all reserves fit this description. The Blackfoot had been persuaded to sell almost half their reserve to raise money during the land boom of 1912 to 1920, so they had large funds which enabled them to provide their members with modern frame houses and regular supplementary food rations. Among the Bloods, too, were affluent farmers who appeared to be weathering the severe economic conditions on the reserve.

When de Grandmaison met the Indians, they no longer dressed like the romantic warriors and nomads of a century earlier. The men wore shirts, trousers or overalls, cowboy or soft-brimmed hats, and either plain, unbeaded moccasins or cowboy boots. They also wore kerchiefs, which the younger men tied around their necks, and the older men used as head scarfs. Often their only Indian adornments were shell earrings or beaded chokers. The women were clad in long, cotton dresses, with brass-studded belts at their waists. They, too, wore kerchiefs and moccasins, as well as shawls over their shoulders. Their most frequent ornaments were earrings and brass wristlets. Both men and women tended to wear their hair long, loose over their shoulders or in braids. Of course, almost everyone had a buckskin costume, dress or other regalia packed away for use on special occasions such as parades and ceremonies. The physical evidence had almost disappeared, but behind the denim overalls, cotton dresses and crude log cabins, there still existed a rich and colorful culture.

The majority of Indians spoke only their native tongue since they had not attended school. In the early days when residential schools had been established on the reserves, Indian children lived away from their families at the school, and most did not stay for the

length of time needed to complete an elementary education. Later it became a law that the children had to attend school, and runaways were returned by the RCMP. The fact of living on reserves, along with the language barrier and the racial and cultural differences, completely isolated most Indians from the surrounding white communities. This was by mutual consent, for most Indians considered white people to be unfeeling, avaricious and domineering, while most white farmers and townspeople judged the Indians to be ignorant, dirty savages. The railway track or road allowance that separated the reserve from the white community was symbolic of the difference in time, culture and customs: for either group to cross was to enter an alien land.

Nicholas de Grandmaison looked past the wretched conditions and destitution; in the faces of the Indians he saw all the evidence he needed of a hundred generations of buffalo hunters and warriors. In their eyes he could see a combination of pride and pathos, independence and subjugation, arrogance and defeat. The faces identified the race, and their eyes told the story.

De Grandmaison was a romantic and an idealist and thought that if a model had the classic features of a Plains Indians he must embody all that was noble and good that the race could offer. In a rather naive fashion he saw all of his native models as wonderful people who were honest, humble and kind. "I love them as fellow brothers," he once said enthusiastically. "They have character, color and history in their blood. I prefer to paint them. They sit quietly and pay attention when you are drawing them. . . . They are unselfish and generous — completely opposite to our modern society. The Indian will never gossip. Their saying is that if you don't like a man, kill him, but if you don't want to kill him keep your mouth shut about him."

In fact, the artist's models were like any other people. Some, such as Camping Place Woman (figure 20) and Good Man (figure 43), were loved and respected in their communities. Others, like Longtime Squirrel (figure 14), had a reputation for being jealous and vindictive, and de Grandmaison's favorite model, Big Kidney (figure 16), was shunned and feared by many of his tribesmen when he was drunk.

Subtle cultural differences apparently passed by de Grandmaison, and he was not aware of many Indian customs. For instance, if one of his elderly subjects had been active in religion or warfare he might refuse to divulge his name, but the artist did not realize that the model believed himself to be so famous that to speak his own name would be considered bragging. As a result the person in the portrait was not named or was left for someone else to identify.

A more common problem was the multiplicity of names. Nearly every Indian painted by de Grandmaison had at least two names, and a Blackfoot mght have five or six. For when a boy was born he was given a child's name which stayed with him until he was a teenager; then he got a man's name — often one which had belonged to an ancestor. As he went through life he would be given a new name each time he performed a heroic or notable deed such as

Sarcee Indians painting designs on a tepee which is laid out flat on the ground, Sarcee Indian Reserve.

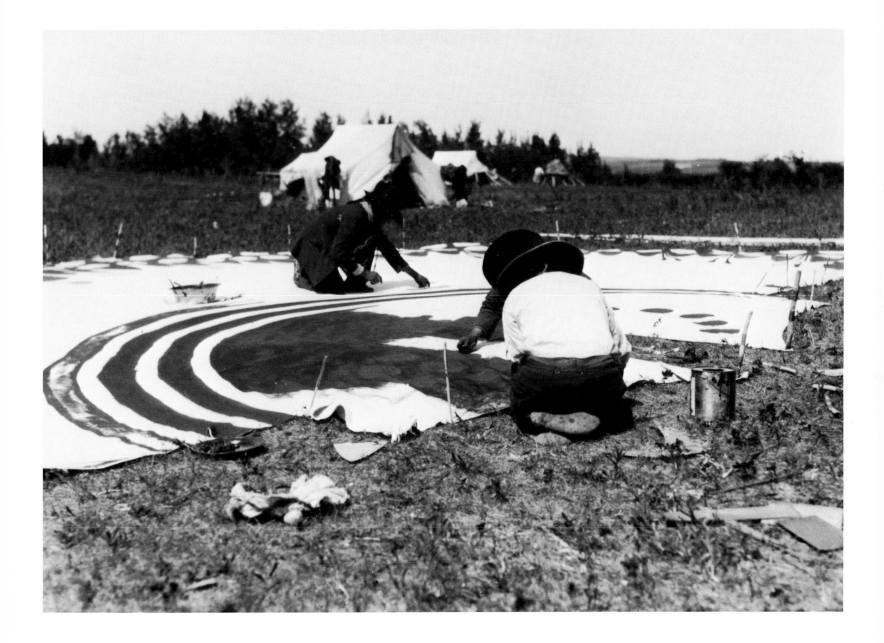

joining a religious society. In theory he discarded one name when he took another but, in fact, many people who had known him by a particular name continued to use it. In addition, a man was often given a nickname which was used by his immediate family.

The situation with a woman's name was simpler. When a girl was born she was named by a patriarch of the family, and he usually chose a name from his own war experiences, hoping that his good luck would be passed on to the child. Hence a woman was often given a warlike name such as Owns a White Shield (figure 12) or Stolen Many Things (figure 58).

To add to the confusion about names, when a man or woman was registered on the government rolls or sent to school, he or she was given a surname — the father's name or one selected by a missionary — as well as a Christian name.

Being a romantic, de Grandmaison wanted to believe that all of his male subjects had been great warriors and he would ask them over and over if they had ever stolen horses or fought against their enemies. In fact, most of them were born too late to have taken part in the Indian wars; they had been children when they settled on the reserves and knew only farming and ranching. Of all the men included in this book, only a handful had any war experiences: Shot Both Sides (figure 19), Favorite Ill Walker (figure 48), Blue Wings (figure 49) and Hungry Crow (figures 2 and 54).

Shot Both Sides, born in 1874, was the son of Crop Eared Wolf (head chief of the Blood tribe) and grandson of the famous head chief Red Crow, one of the signers of Treaty Number 7. Describing his adventures, Shot Both Sides said, "I took part in five raids against the enemy and captured two horses each time. One raid was in midwinter and each time it was against a different tribe — all of them in Montana. I also captured a shotgun in one of the raids. We never killed any of the enemy; neither were any of us killed."

Blue Wings was born in 1870 and as a young man had taken part in several raids, capturing five horses. On one raid he had acted as scout, going ahead of the main party to find an enemy camp and then determining the wisdom of attacking it or not. Like Shot Both Sides, he had never killed an enemy, but once his party had been discovered and the warriors traded shots before escaping.

Hungry Crow had not been as fortunate as his tribesmen in raiding, perhaps because he made no distinction between horses belonging to white men and those of other Indians. In his only Indian raid he had found a lone horse which had wandered away from its owner's tepee and he had ridden off with it just as his enemy appeared. His other three raids had been against white ranchers and he was caught twice, in 1905 and 1907, and sent to prison. In spite of these reverses, Hungry Crow's raids were considered war exploits, and for many years pictographs describing them decorated the tribe's war tepee.

Only a few of the oldest Indians could remember the vast buffalo herds and their life as hunters before the days of the Mounted Police and the treaties with the Queen. In fact, de Grandmaison painted only one man who recalled running buffalo and that was

Favorite Ill Walker, probably the last native person in Alberta to have been involved in such a hunt. This happened in 1881 when he was thirteen years old.

"I remember the last time I saw a wild buffalo on the prairies," Favorite Ill Walker said. "White Calf and Button Chief were the leaders of our party. We had travelled down to the American side in search of buffalo, for our people were starving. At last we came to a place where the American soldiers were issuing food to the Indians."

The soldiers refused to give the Bloods anything to eat and told them they fed only Americans. Then they noticed that Button Chief wore a medal given to him in 1855 when his tribe had signed a treaty with the Americans.

"They welcomed us," Favorite Ill Walker said, laughing, "and gave us flour, bacon, beans, coffee. White Calf said that it would be foolish to go on towards the Bearpaw Mountains, as we would probably run into the Crees, Assiniboines or Sioux and we would all be killed. But we wanted buffalo meat so we decided to go on."

A few days later the scout heard someone singing the Buffalo Song. He found a lone Blackfoot who told of killing eight buffalo from a large herd. He had picked out the strays but had not disturbed the main herd which was about two days' travel ahead. As soon as the scout spread the news, everyone lit their campfires and began singing. "Soon there were lights shining in every tepee and everybody was happy."

Next morning the Bloods travelled towards the Little Rockies and on the second day came to a place called Hairy Caps, where there were two hills covered with trees. Nearby, in the valley of Beaver Creek, they found the buffalo.

"White Calf told us to prepare our buffalo runners," the old patriarch recalled. "When everybody was ready, he shouted the signal, and we all rushed over the edge of the hill overlooking Beaver Creek. On the other side, the valley was thick with buffalo. Our horses rushed into the main herd and we were successful in killing many buffalo before the others ran away. That was the last time I ever saw a wild buffalo. We rested for a while. By the time we passed Fort Benton [Montana] on our way home, our people were starving again. We had not seen another buffalo. That was when we knew there was no more hunting on the prairies and we had to go back to Canada where the Mounted Police would give us food at Fort Macleod."

De Grandmaison painted two other men who might be considered warriors, even though their prey was white men's cattle: Tough Bread (figure 47) and Longtime Squirrel (figure 14). When they were young men, the government had cut the rations given to the Blood Reserve, and to help feed their hungry people the two men and some friends had begun to kill cattle that strayed onto the reserve. Tough Bread and Longtime Squirrel were eventually caught and sent to jail for two years but, instead of being disgraced by the imprisonment, they became local heroes because they had been stealing from the rich to help the poor.

A group of mounted Blackfoot Indians wearing ceremonial dress in honor of the Royal Visit of 1901, Shaganappi Point, Calgary.

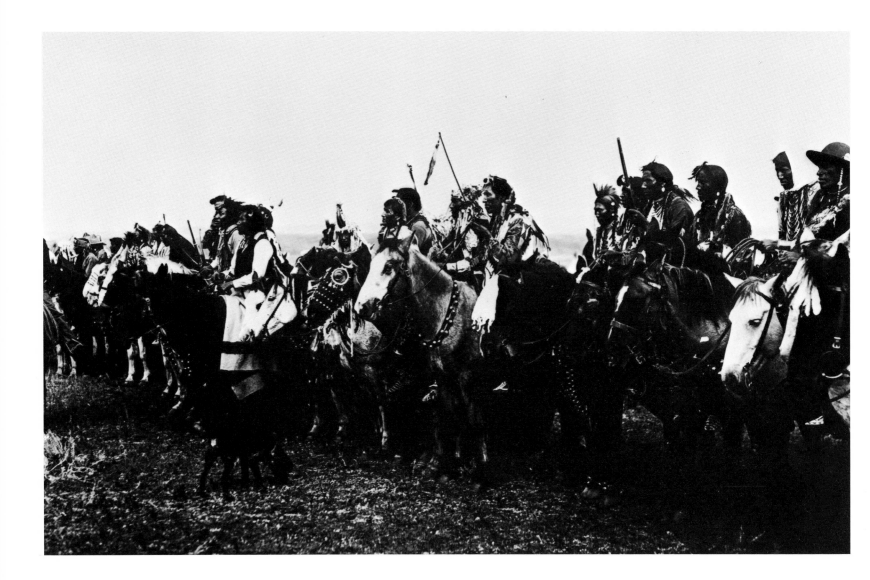

None of the Plains Indian tribes had a written language, so the history and traditions of their people were passed down orally. Consequently, many elders were expert storytellers, entrancing their children with tales of ghosts, supernatural events and the exploits of their ancestors. Some of the Indians whom de Grandmaison painted were particularly gifted in this field, especially Sinew Feet (figure 45). Once, with his wife and children gathered around him in his home, he told a ghost story which "I know is true because I saw it myself." He raised his arm as a gesture for attention and began.

"It happened when I was about twenty years old. One day I went to Big Calf's place to see a friend of mine named Black Rock. When I got there, he said that Big Calf would soon be returning with someone from the land of the dead. He asked me to stay, so I went over and sat down at the end of the log cabin. A little while later some other people, including Tough Bread (figure 47), came in and joined us.

"Later in the evening," he continued, his voice dropping to heighten the dramatic effect, "the lanterns were put out and a candle was placed under the stove. That was the only light. Then we heard a knock on the door and I thought it had to be the ghost. The door was opened, but I didn't see anyone come in. A blanket was laid for the ghost to sit upon and I had a feeling he was in the room. It was the ghost of Eagle Ribs who had died several years earlier. Soon after he died, Tough Bread, who had been camped beside him, had moved away to another location.

"I had never known Eagle Ribs, so the ghost asked me who I was. I told him and he said, 'Oh yes. You must have been very young.'

"The ghost then spoke to Tough Bread, asking him why he had moved away. Tough Bread did not answer but fell down and covered himself with a blanket. When it was pulled away, his face was covered with blood."

Sinew Feet smiled as his children followed the story in rapt silence. "We could hear bells ringing in the rafters," he added, "and while they were still ringing, Tough Bread's face was covered up again. When the ringing stopped, the blanket was removed and the blood was gone! I saw it happen. I was there."

Every tribe had its good storytellers and favorite stories. The Crees were fond of supernatural tales about cannibal spirits, skeleton wraiths, monsters and the Little People, the *Maymaykwaseewuk*. One Cree storyteller described the Little People she had seen as a young girl. "They were only about eighteen inches high, and they had big bellies and white faces. Their ears were big, too, and they looked something like little bears." It was believed that the Little People disappeared by running quickly in a circle and always ran away when people came near, though they left stone arrowheads for hunters. They were said to be good spirits who helped the Indians whenever they could.

All the Indians whom de Grandmaison painted must have had intriguing stories to tell about their horse raids or those of their ancestors, legends of the supernatural and personal adventures. The

tragedy is that theirs was an oral history and, at the time
de Grandmaison was working among them, few people took the
trouble to record their stories. The artist was almost alone in his
dedicated attempt at preservation as he moved from reserve to
reserve, recording the faces that for him typified a people who were
being forgotten in their land and were disappearing into an alien
society.

"Their untouched blood and character show up in their faces,"
he once told a reporter. "These are my children, and I wish to
preserve their faces for posterity. I shall paint them until I die."

1
Wolf Tail, *Apisoh'soyi*
Peigan Indian
Brocket, Alberta
1930
Pastel on paper, 45 x 60 cm
See also figures 52 and 55

Born in 1872, Wolf Tail was one of the
leading doctors and herbalists on the Peigan
Reserve. He was employed at the ration
house for many years, butchering and
issuing beef. While an Indian Department
employee, he was one of fourteen men who
were persuaded by the Canadian government
to sign a document authorizing a vote to
surrender almost a quarter of the reserve.
This was done supposedly to increase the
tribal funds. The petitioners claimed they
had not been told what they were signing
and, in spite of legal action by the Tribal
Council to block the deal, the land was sold
to farmers and speculators.

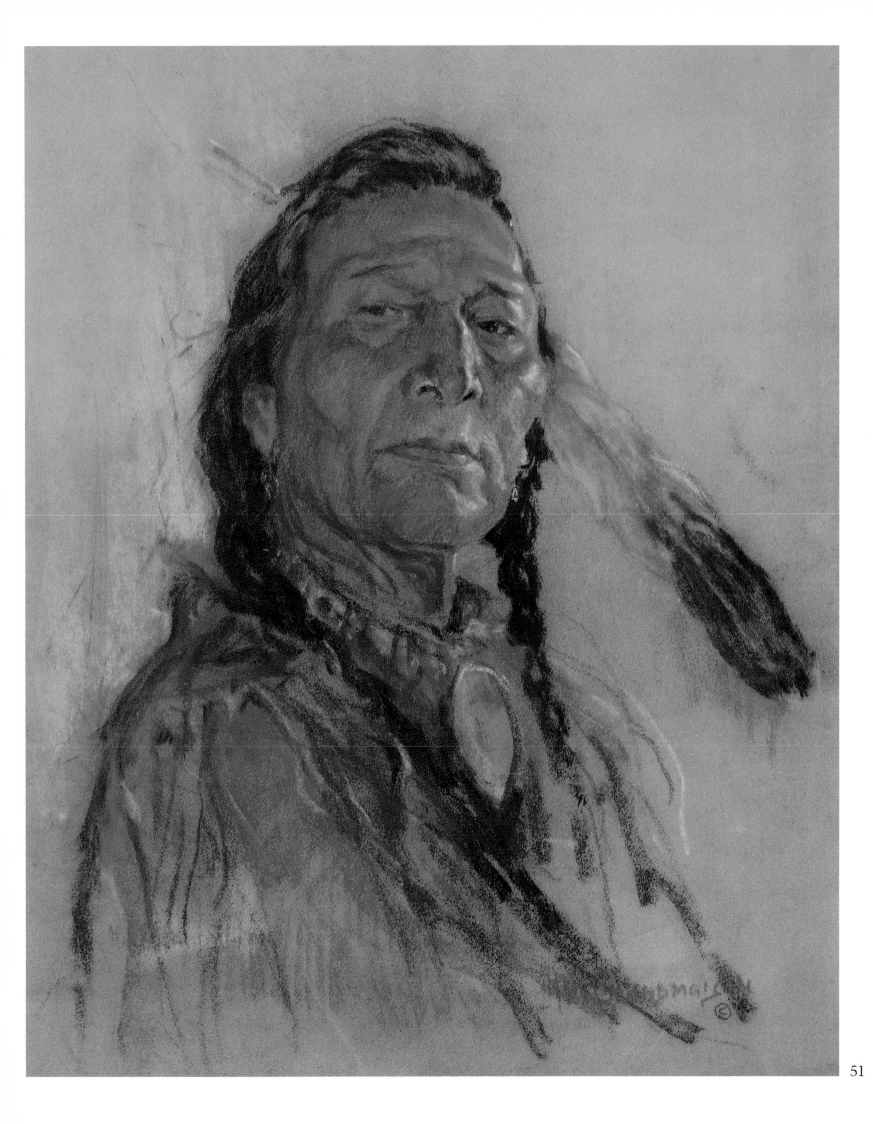

2
Hungry Crow, *Maitsto'notsi*
Blood Indian
Cardston, Alberta
1934
Pastel on paper, 33 x 42 cm
See also figure 54

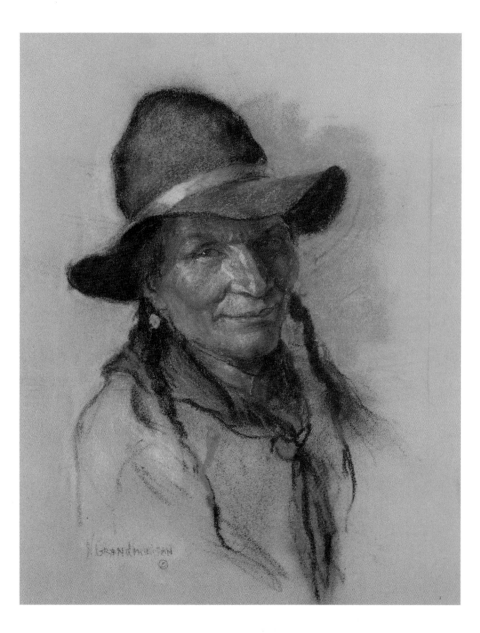

Born in 1875, Hungry Crow had taken part
in horse raids, but three of his four forays
had been against white ranchers. As a result,
he served two prison terms just after the
turn of the century, but his actions were
praised by the Bloods and he was always a
respected figure on the reserve. He married
Calling from the Side and, with his relative
Shot Both Sides (figure 19), farmed a small
acreage.

3
Fast Walker, *Eh'komo*
Peigan Indian
Brocket, Alberta
1938
Pastel on paper, 44 x 58 cm

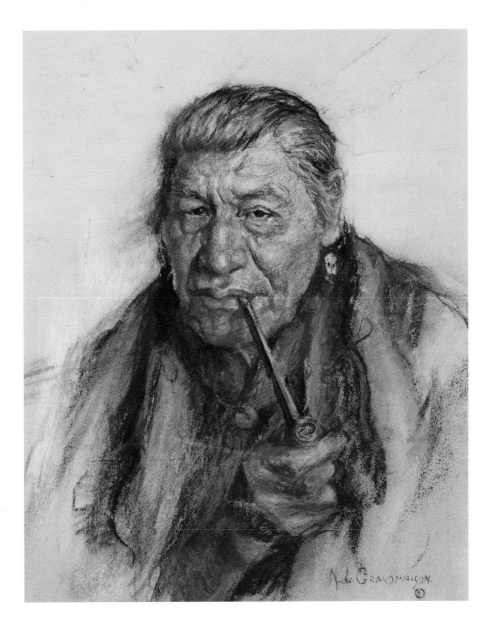

Fast Walker's nickname was "Speedy." Born
in 1865, he was registered on the
government rolls as Little Girl. He was a
noted prairie chicken dancer in his youth
and in later years was the owner of a
medicine pipe. He lived to be almost a
hundred years old.

4
Man
Plains Cree
Fort Qu'Appelle, Saskatchewan
1930
Pastel on paper, 37.5 x 53 cm

5
The Walker, *Pemota*
Cree Indian
Balcarres, Saskatchewan
1930
Pastel on paper, 64 x 84 cm

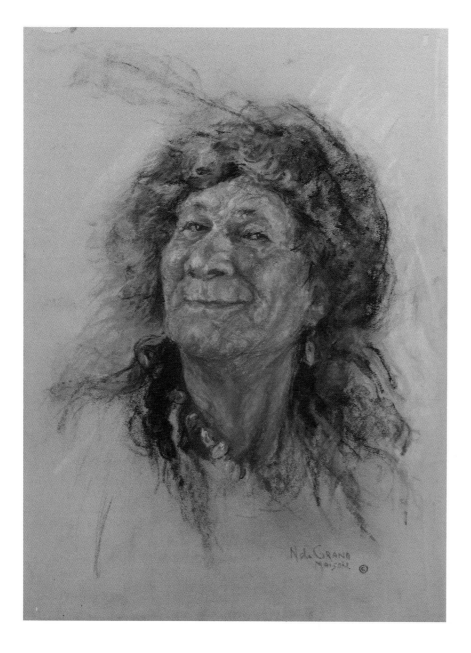

Born in 1864, *Pemota* was one of the first
Plains Indians painted by de Grandmaison
and over the years remained a favorite
model. A brother of Chief Star Blanket,
Pemota married the widow of Buffalo
Blanket from the nearby Okanese Reserve in
1906 and transferred there. He was a farmer
but was better known for his participation in
local fairs and celebrations, where he was a
familiar sight in his colorful buckskin
costume. His son John Pemota was one of
the first Indians to enlist in the Canadian
army during World War I. After his wife died
in 1940, *Pemota* returned to the Star Blanket
Reserve and died there twelve years later.

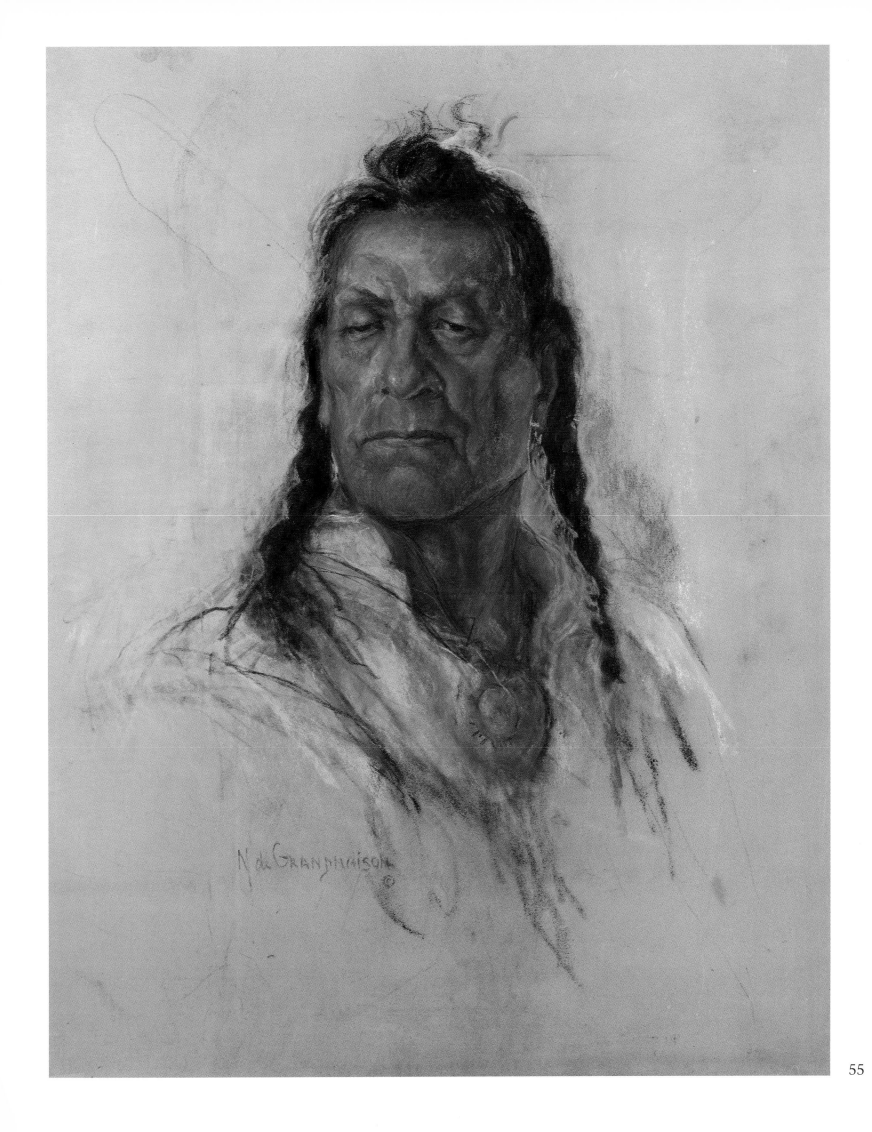

6
Heaven Fire, *Tsa-la'wa-ko*
Sarcee Indian
Sarcee Indian Reserve, Alberta
1932
Pastel on paper, 56 x 76 cm

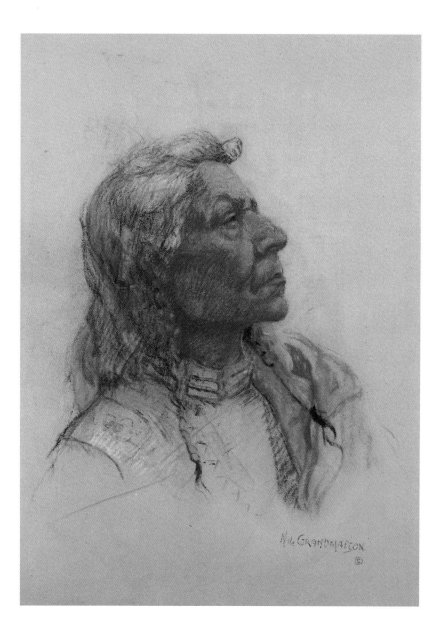

Born in 1873, Heaven Fire lost his mother
when he was only nine years old and was
raised by his father and relatives. When he
was sixteen, his father died, but the boy had
become so independent that he was given
adult status. Although his personal name
was Buffalo Fetlock, the Indian agent
registered him on the government rolls
under his father's name, Heaven Fire, and
the name persisted through succeeding
generations of the family. He did not attend
the mission school, but was highly respected
as one of the old-time Indians on the reserve.

7
Blue Flash of Lightning, *Cheepaythaquakasoon*
Cree Indian
Waterton Park, Alberta
1934
Pastel on paper, 33 x 50.5 cm

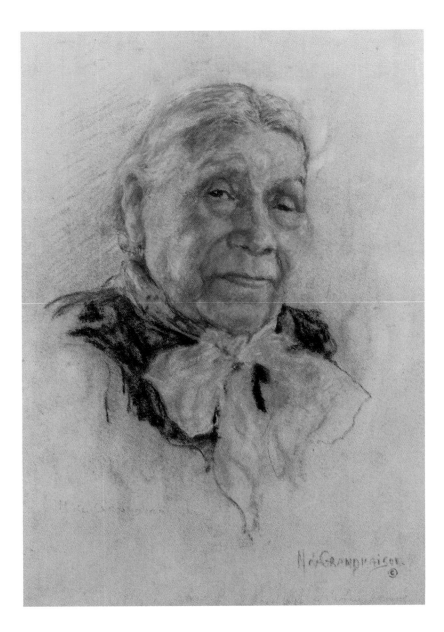

When she was seventeen, Blue Flash of
Lightning married the famous frontiersman
John "Kootenai" Brown who was the first
superintendent of Waterton Lakes National
Park. According to Indian traditions, he
traded five horses for her. His nickname for
her was *Nitchimoos*, or "Sweetheart," and
she remained at his side until he died in
1916. Under her other name, Isabella Brown,
she had become almost as well known as her
husband by the time she died in 1935.

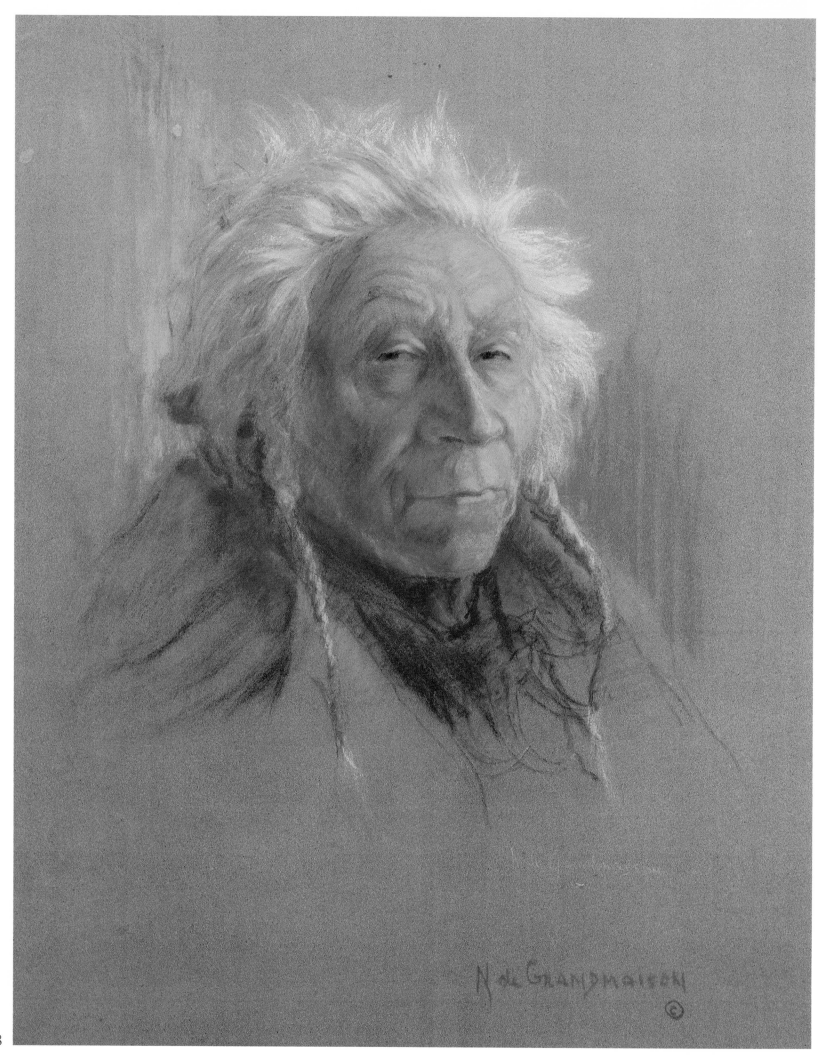

8
Buffalo Bow, *Kahmoostoos-wahchappo*
Cree Indian
Balcarres, Saskatchewan
1930
Pastel on paper, 50 x 65 cm

9
Woman and Child
Blackfoot Indians
Cluny, Alberta
1936
Pastel on paper, 46 x 58 cm

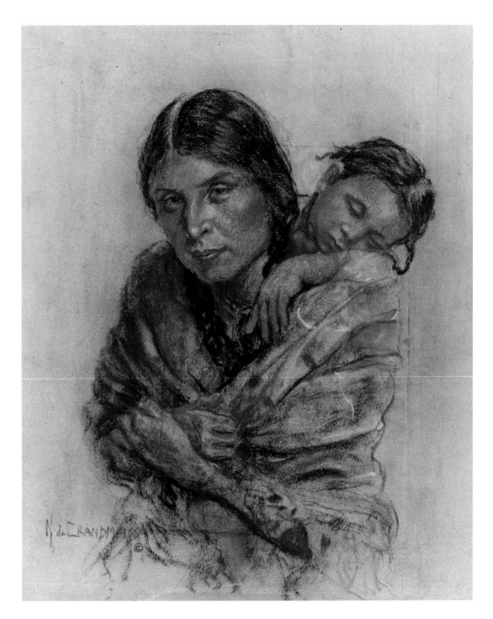

Born in the 1850s, Buffalo Bow was the son
of Red Bird and grandson of *Okanese*, chief
of his band. He was a prominent and
well-known figure highly respected for his
wisdom and leadership. For many years he
was the oldest man on the File Hills
Reserve. He died in 1944 when he was in his
nineties.

10
Across the Mountain, *Satoht*
Blood Indian
Glenwood, Alberta
1938
Pastel on paper, 38 x 56 cm

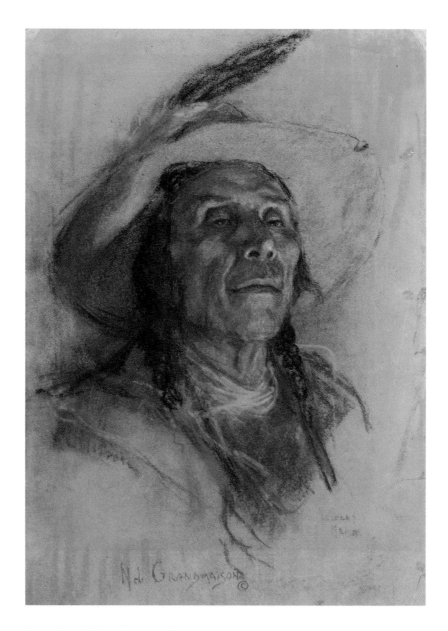

Born in 1872, Across the Mountain was a
member of the Hairy Shirts band. Although
a member of the Pigeons and the All Brave
Dogs societies, he was not active in tribal
ceremonies. De Grandmaison was unable to
complete this portrait while Across the
Mountain was sitting for him, so he used
Black Sleep (figure 17) as his model to finish
it. Across the Mountain died in 1950.

11
Chief Body, *Nina-stomi*
Blood Indian
Standoff, Alberta
1933
Pastel on drawing paper, 48 x 63.5 cm

12
Owns a White Shield, *Ksik-aotan*
Blood Indian
Standoff, Alberta
1938
Pastel on paper, 52 x 74 cm

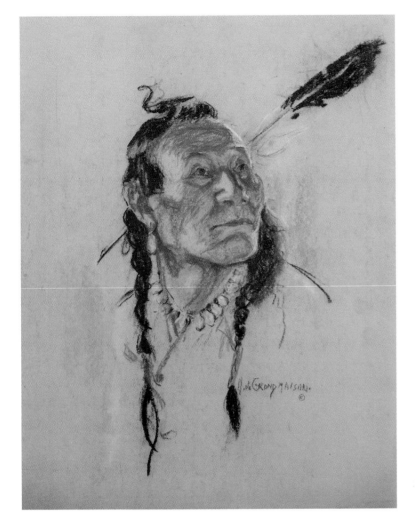

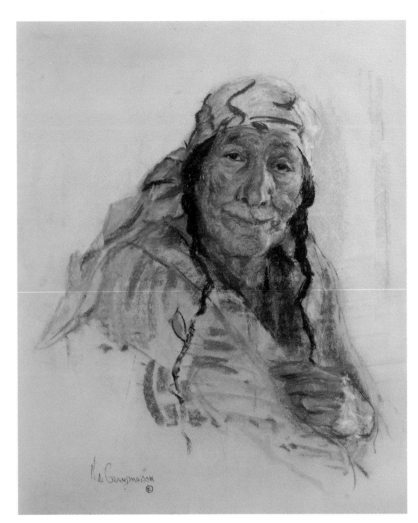

Chief Body was born in 1879 and also had the names Favorite Child and Many Beaver People. He received the name Chief Body when he reached maturity. He was a member of the Horn Society, the leading religious organization of his tribe, as well as several other secret societies. According to tradition, the name Chief Body had been given to a handsome warrior who refused to attack an enemy in hand-to-hand combat. In anger, a medicine man had named the warrior Chief Body, saying that he was a chief because of his fine physique, not because he was a brave leader.

Born in 1871, Owns a White Shield was a daughter of treaty chief White Striped Dog. She was first married in her early teens and had a son named Running Crow, who went to the Catholic industrial school but died a few years later. After separating from her first husband in about 1890, she wed Spider. They had three children, but none lived to maturity. They had no other family nor did they ever settle into the farming life of the reserve. Instead, Spider served as a Mounted Police scout, and the couple camped near friends and relatives in the Standoff area. They were always together and Owns a White Shield was remembered as a kind and gentle woman.

13
Child
Blackfoot Indian
Gleichen, Alberta
1936
Pastel on paper, 48 x 67 cm

14
Longtime Squirrel, *Mesamikayisi*
Blood Indian
Cardston, Alberta
1938
Pastel on paper, 38 x 56 cm

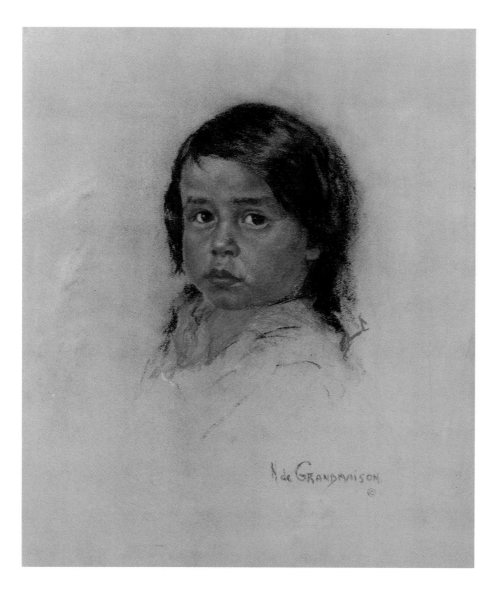

In the 1890s Longtime Squirrel was one of a cattle-killing ring that was caught and sent to prison. Because he had given much of the meat to starving members of the tribe, his actions were praised by his people. After his release from prison, he had a vision about horses wandering freely on the prairie as far as the eye could see. Taking this as a sign, he began to raise his own stock and by 1939 had almost 700 head, one of the largest herds on the Blood Reserve. He kept them as a sign of wealth and also provided rodeo stock for wild horse races and bucking horse competitions. Three times a member of the Horn Society, he owned a medicine pipe and belonged to several other religious societies. He died in 1945.

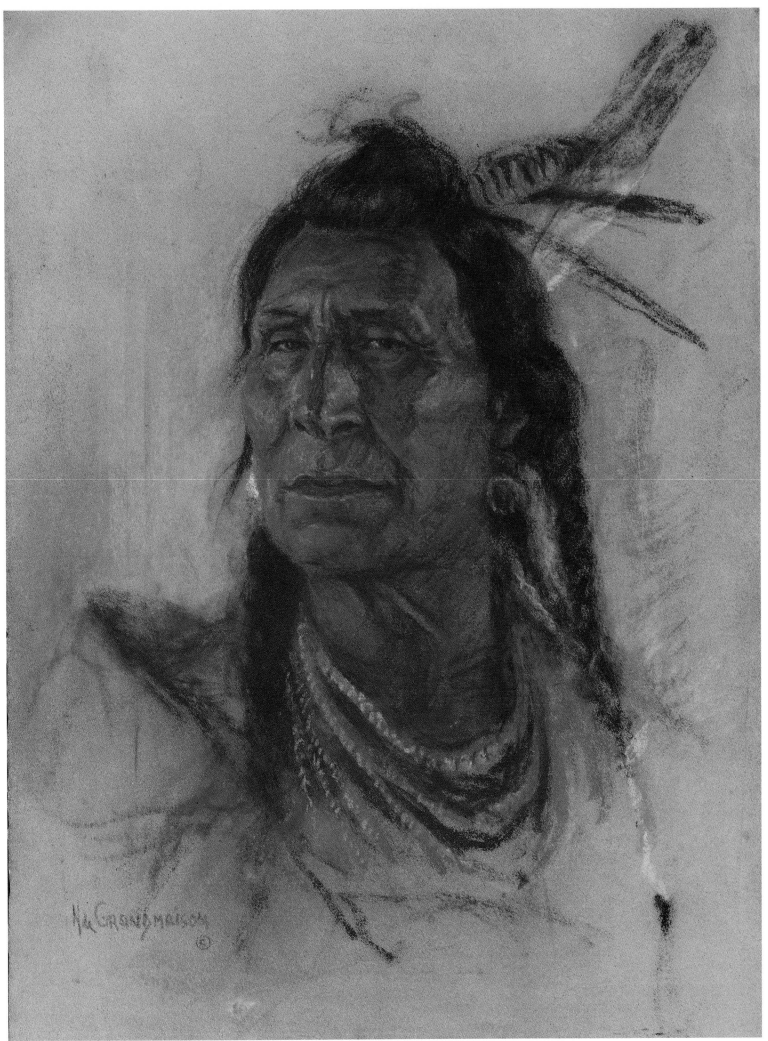

N. de Grandmaison

15
Crawling Walker, *Awoh'pi*
Blackfoot Indian
Gleichen, Alberta
1934
Pastel on paper, 38 x 55 cm

16
Big Kidney, *Omukoto'ki*
Blackfoot Indian
Gleichen, Alberta
1935
Pastel on paper, 58 x 46 cm

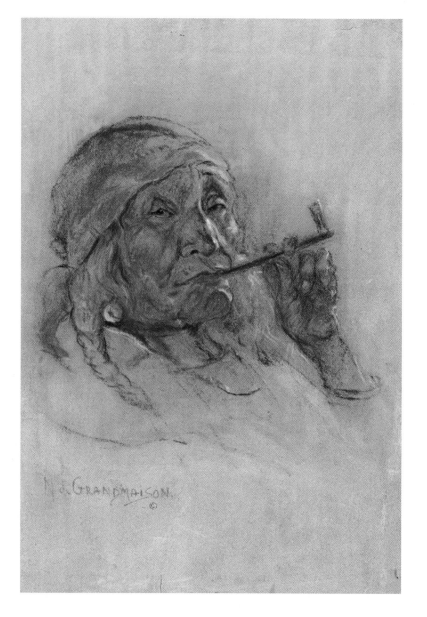

Crawling Walker was a holy woman of the
Blackfoot and sponsored many Sun Dances
though she was badly crippled. After her
death, the religious traditions were carried
on by her daughter, Mrs. Mary Water Chief.

Big Kidney, or Herbert Lawrence, was one of
de Grandmaison's favorite subjects. Born in
1873, Big Kidney was a successful farmer,
owning one of the first automobiles on the
reserve. He was also known as Gros Ventre
Man and Rainy Chief. As he grew older, he
spent more and more time in Calgary where
he frequently visited de Grandmaison. He
died in 1951.

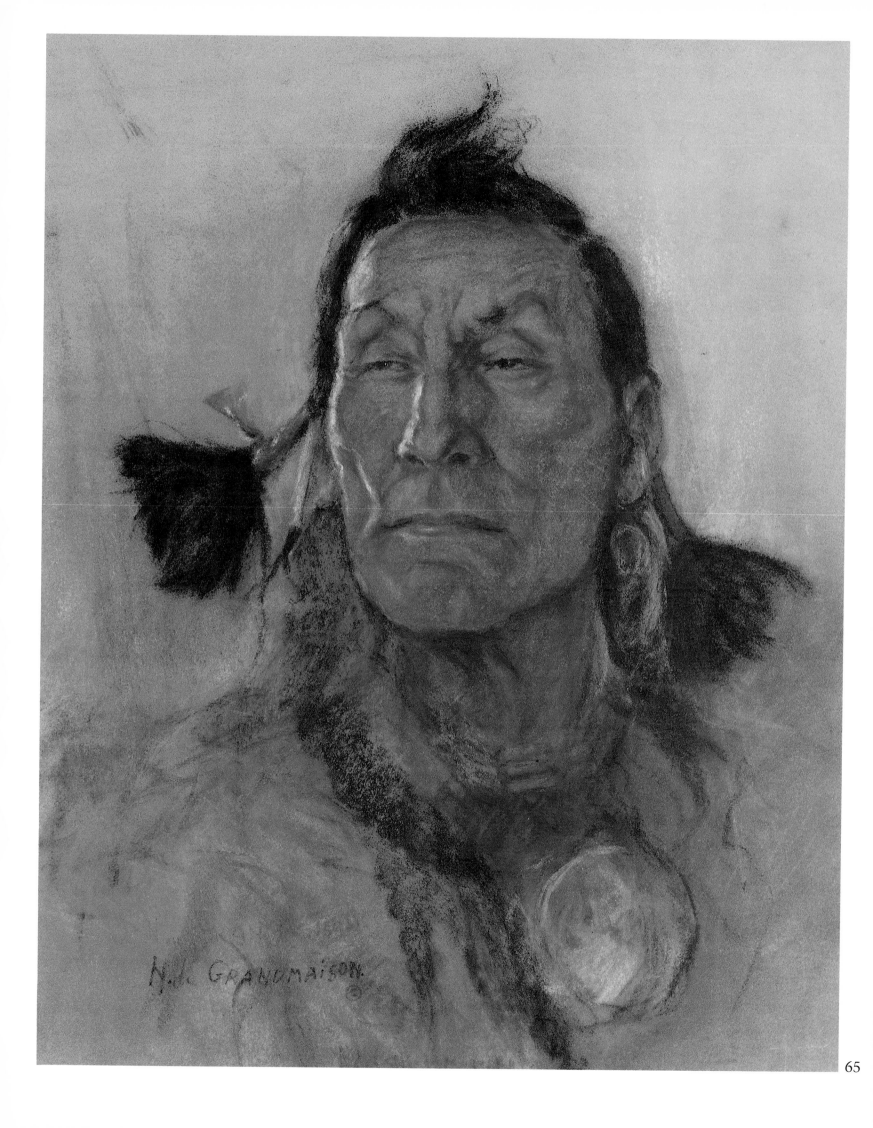

Born in 1890, Black Sleep had two or three
wives, all of whom died when he was still a
young man. According to gossip, he could
not find another wife because he was too
difficult to live with. As a result, even
though he was prosperous, he lived alone. In
the 1950s he contracted tuberculosis and
was committed to the Charles Camsell
Indian Hospital in Edmonton, Alberta. He
died shortly after his admission to the
hospital.

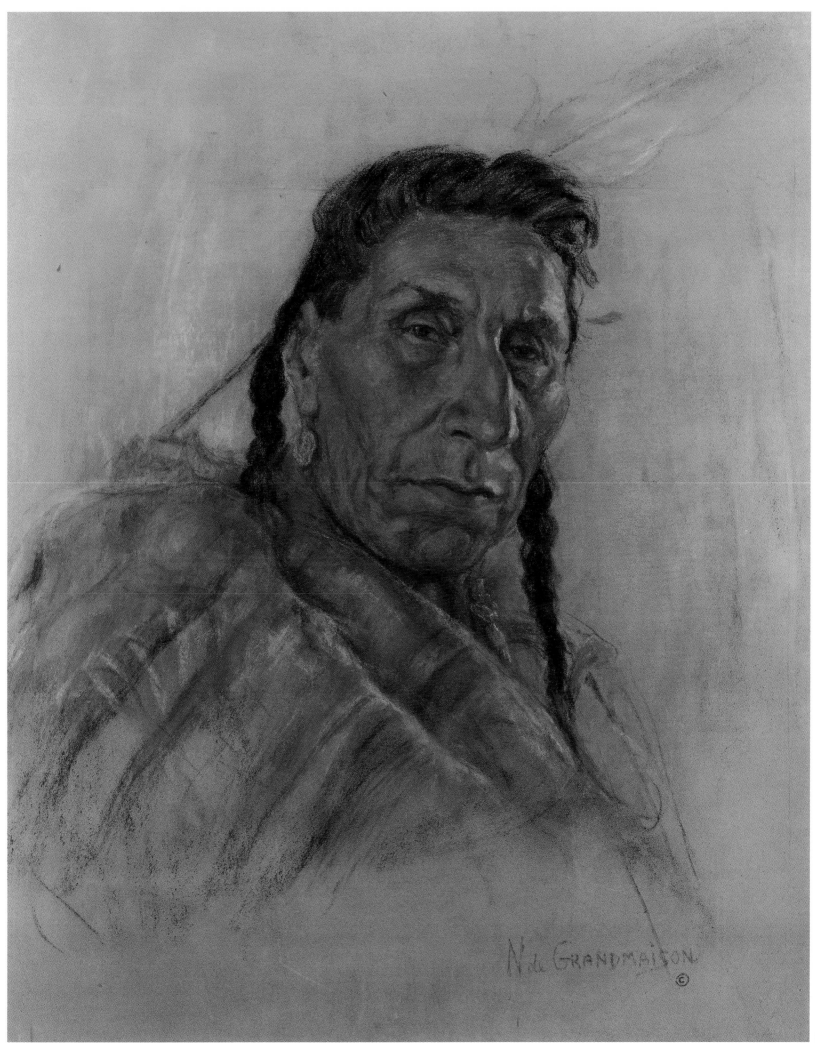

N de Grandmaison

18
Is He Here?, *Ikinai-towa*
Peigan Indian
Brocket, Alberta
1949
Pastel on paper, 46 x 60 cm

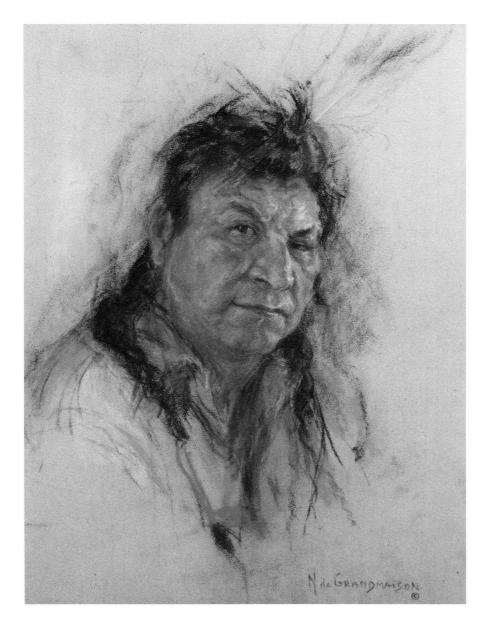

Born in 1908, Is He Here? was a grandson of
head chief Crow Eagle. He was crippled as a
child and never married but became known
as a good storyteller. Is He Here? was also
known as Aldred Small Legs and had the
second Indian name Different Horns,
Kistoo'tskina. He died at the age of seventy.

19
Shot Both Sides, *Atso'toah*
Blood Indian
Glenwood, Alberta
1949
Pastel on paper, 50 x 65 cm

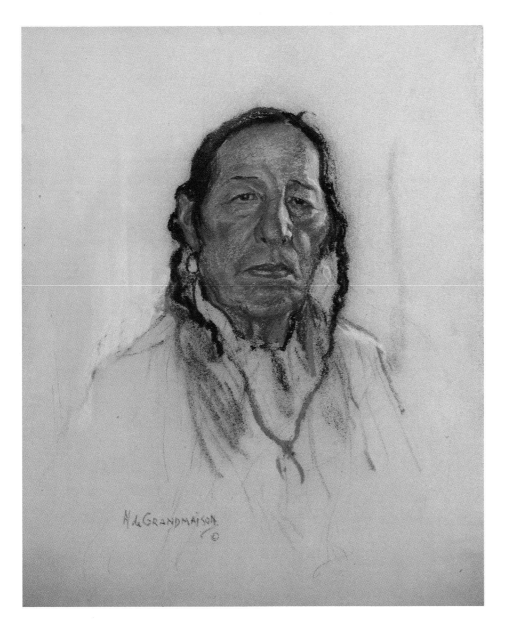

A son and grandson of leading chiefs of the
Blood tribe, Shot Both Sides was given the
name *Atso'toah*, literally "shot at from both
sides," commemorating a war experience of
his grandfather. Shot Both Sides took part in
five raids against enemy tribes, capturing
two horses each time. In 1913 he was elected
chief of the tribe and was respected for his
diplomacy and strong leadership. His second
marriage was to Longtime Pipe Woman
(figure 60). A supporter of native traditions
and religion, he helped his tribe to maintain
a sense of identity and pride. He died in 1956.

20
Camping Place Woman, *Mak-goh-ga*
Sarcee Indian
Sarcee Indian Reserve, Alberta
1948
Pastel on canvas, 64 x 84 cm

21
Good Rider, *Matso'kitopi*
Peigan Indian
Brocket, Alberta
1940
Pastel on canvas, 55 x 70 cm
See also figure 39

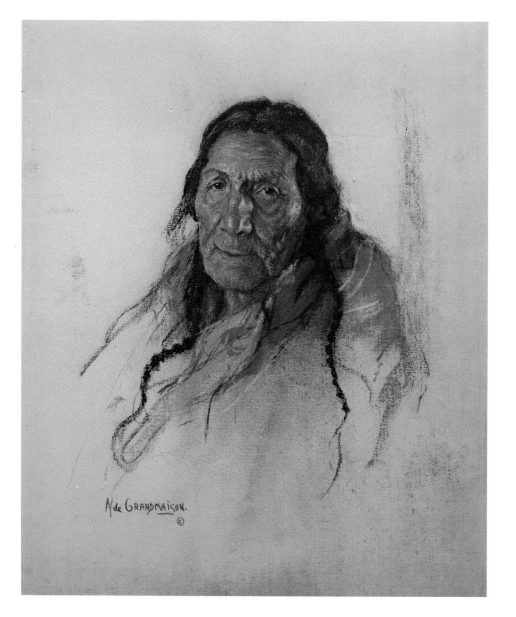

Camping Place Woman, or Mary One Spot, was born in 1873 and later became the wife of Dick Starlight, a chief of the Sarcee tribe. One of the most respected women on her reserve, she died in 1956.

The son of the great Peigan chief Brings Down the Sun, Good Rider was born in 1879 and was originally known as Double Walker. Later, his name was changed to Riding a Good Horse, which was shortened to Good Rider. He was a well-known horse breeder. Like his father, Good Rider was a leader and served on the Tribal Council for twenty years until his death in 1958.

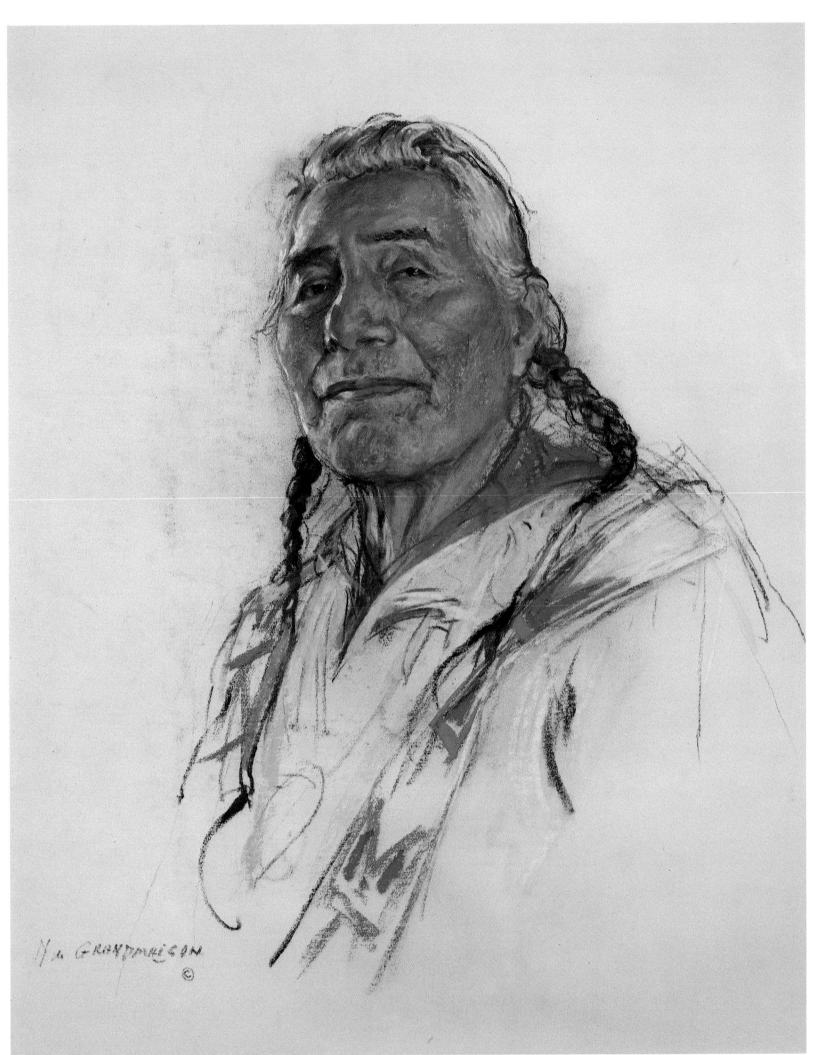

N.L. GRANDMAISON ©

22
Small Person, *Ski-n*
Stoney Indian
Kootenay Plains, Alberta
1948
Pastel on paper, 40 x 56 cm

23
One Gun, *Nitai'namuka*
Blackfoot Indian
Cluny, Alberta
1942
Pastel on paper, 66 x 86 cm
See also figure 57

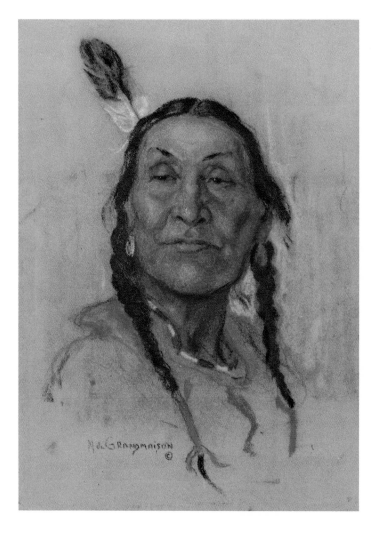

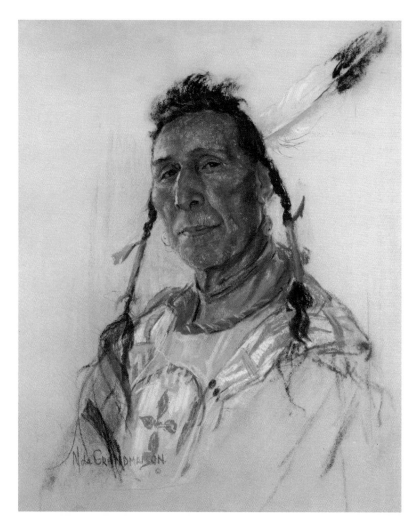

Small Person was born about 1870 and was christened Silas Abraham. Later he married a daughter of Jopie Beaver, a hunter in the Kootenay Plains at the head of the North Saskatchewan River. Small Person knew the whole region intimately as a hunter, guide and trapper. About 1890 he built a cabin on Abraham Flats and broke the first soil in the region. When other Stoneys joined him, he was instrumental in having the area set aside as an Indian reserve in 1947. Small Person died in 1965 and later, when his homestead was flooded by the Bighorn Dam, the resulting lake was named Abraham Lake in his memory.

One Gun (an abbreviation of Taking One Gun) was born in 1884, the son of Owl Child and grandson of The Sun, a famous warrior chief. One Gun established his farm in 1912 and was a prosperous cattle owner, but preferred to be involved with ceremonial life. He and his wife sponsored five Sun Dances, and he owned three medicine pipes, including the venerable Ghost Pipe. He belonged to the Horn Society and other secret societies. His tepee was well known at the Calgary Stampede which he attended from its inception in 1912. Loved and respected, One Gun died in 1973, having served for thirty years as a member of the Tribal Council.

24
Big Thunder, *Mu Taga*
Stoney Indian
Morley, Alberta
1949
Pastel on paper, 56 x 76 cm

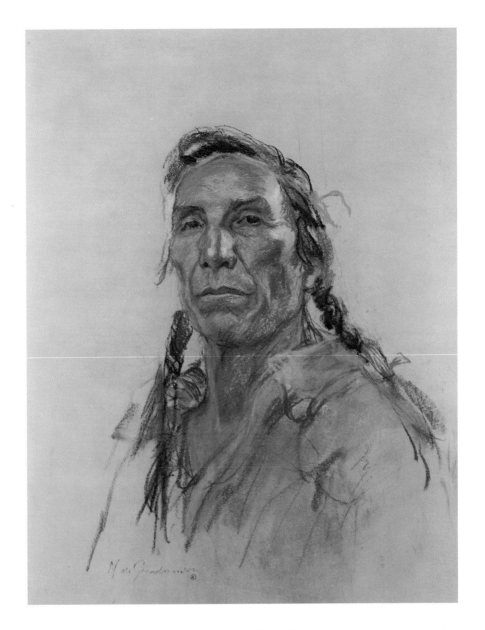

Also known as Amos Amos, Big Thunder
was a hunter and guide in the foothills near
Banff National Park in Alberta. He was a
skilled horseman, participating in
calf-roping events at the Calgary Stampede
and later operating his own riding school at
Morley. For years he was on the organizing
committee of Banff Indian Days, an annual
festival of cultural and athletic events. He
was a doctor and medicine man.
"Sometimes Indians were sick and they call
me," he told de Grandmaison. "I take my
drum, go up there and sit pretty close. I sing
a little, I give them medicine to drink, and
after a while they are all right." Big Thunder
died in 1963.

25
Man
Cree Indian
Fort Qu'Appelle, Saskatchewan
1940
Pastel on velour paper, 52 x 66 cm

26
The Stump, *I'somi-aki*
Blackfoot Indian
Gleichen, Alberta
1940
Pastel on paper, 65 x 85 cm

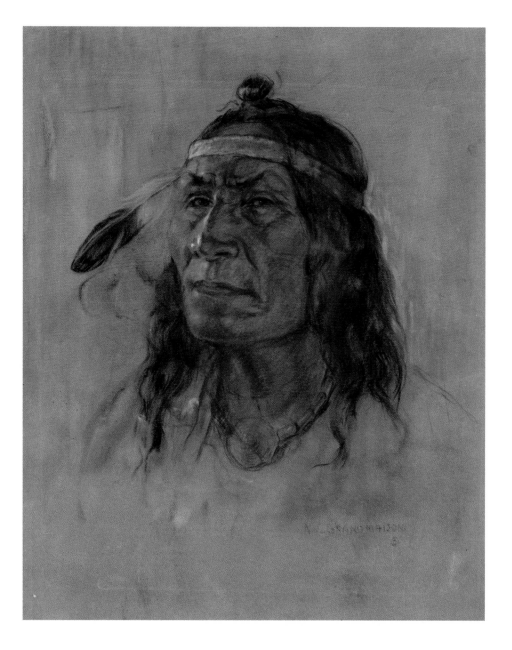

"The Stump was a grand old man," recalled Blackfoot Indian agent George H. Gooderham. "He was a very big man, truly a wonderful picture dressed in his native costume. He tried to adapt himself to white ways and was the first of his age to take anaesthetic when his teeth were being removed at the local hospital. The doctor stated it was quite entertaining because he sang war songs while he was under the ether." The Stump, also known as Eagle Robe, was one of the first men on his reserve to begin farming. He died in 1951 at the age of eighty-two.

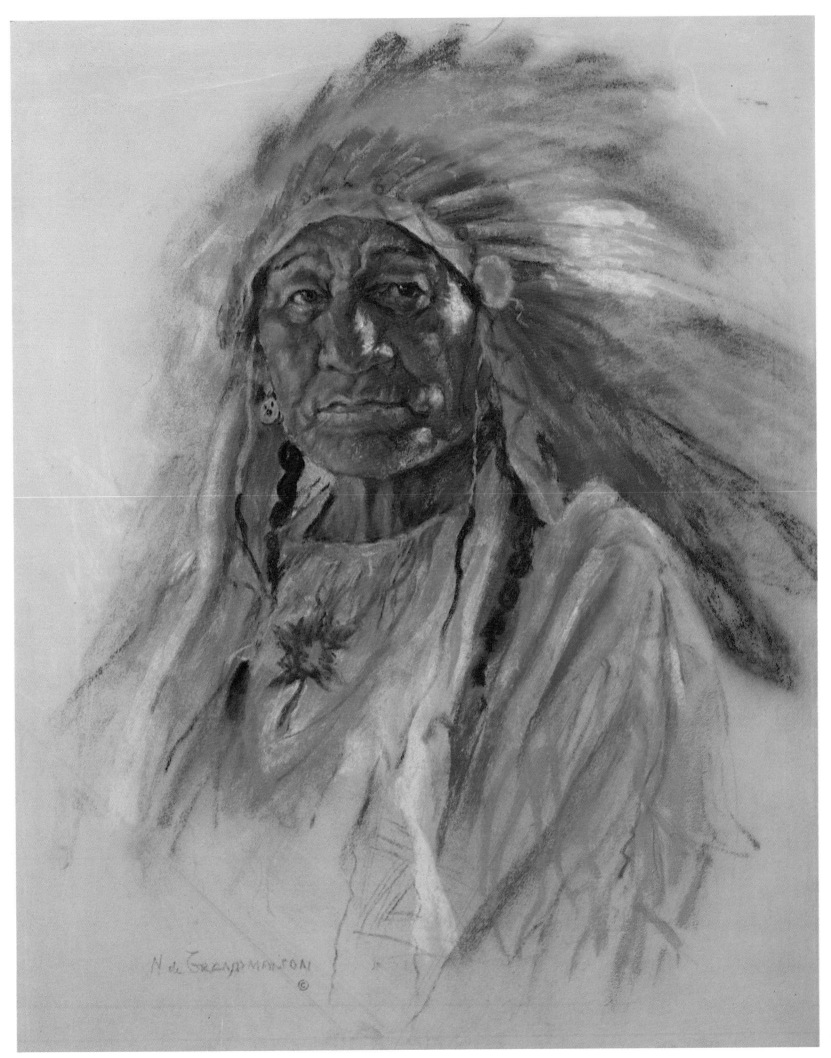

N de GRANDMAISON

27
Sacred Owl, *Natoi'sepisto*
Peigan Indian
Brocket, Alberta
1942
Pastel on paper, 38 x 56 cm

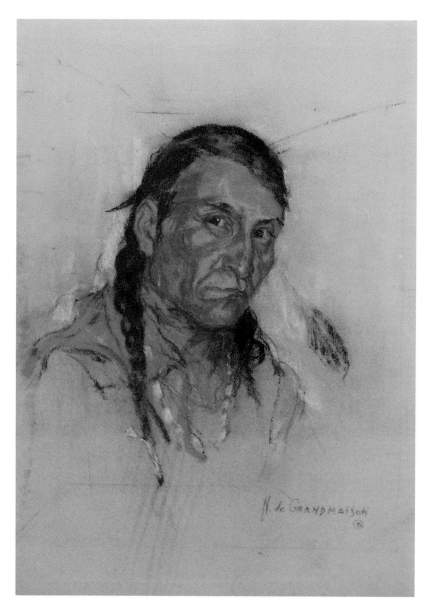

One evening de Grandmaison was attending
an Indian rodeo and saw a beautiful Peigan
girl. He asked her name, but she ran away.
Later, he learned that she was the daughter
of Sacred Owl and went to see if he could
paint her. The girl refused, but the artist
found her father Sacred Owl to be a good
subject. Sacred Owl was born in 1887 and at
the age of ten suffered a stroke that rendered
him deaf and dumb, so he could
communicate only through Indian sign
language. Besides his registered name, his
other names were Gopher and Yellow Horse,
while his nickname was *Muki'na*.

28
Wolf Leg, *Makoy'okut*
Blackfoot Indian
Gleichen, Alberta
n.d.
Pastel on paper, 38 x 50 cm

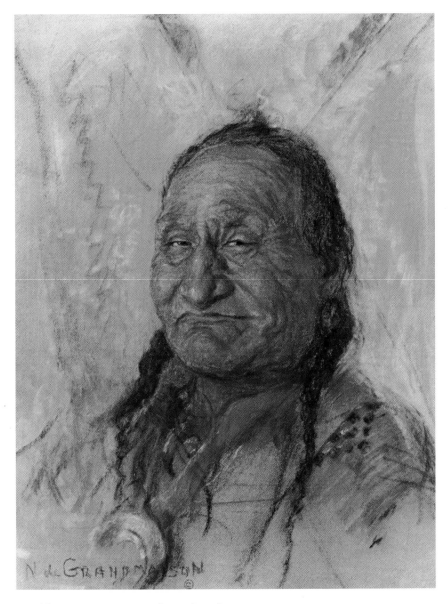

Wolf Leg was remembered as having six toes
on one foot. He was supposed to have had a
twin who was never born. Consequently, he
was considered to be a combination of the
two, as indicated by his extra toe.

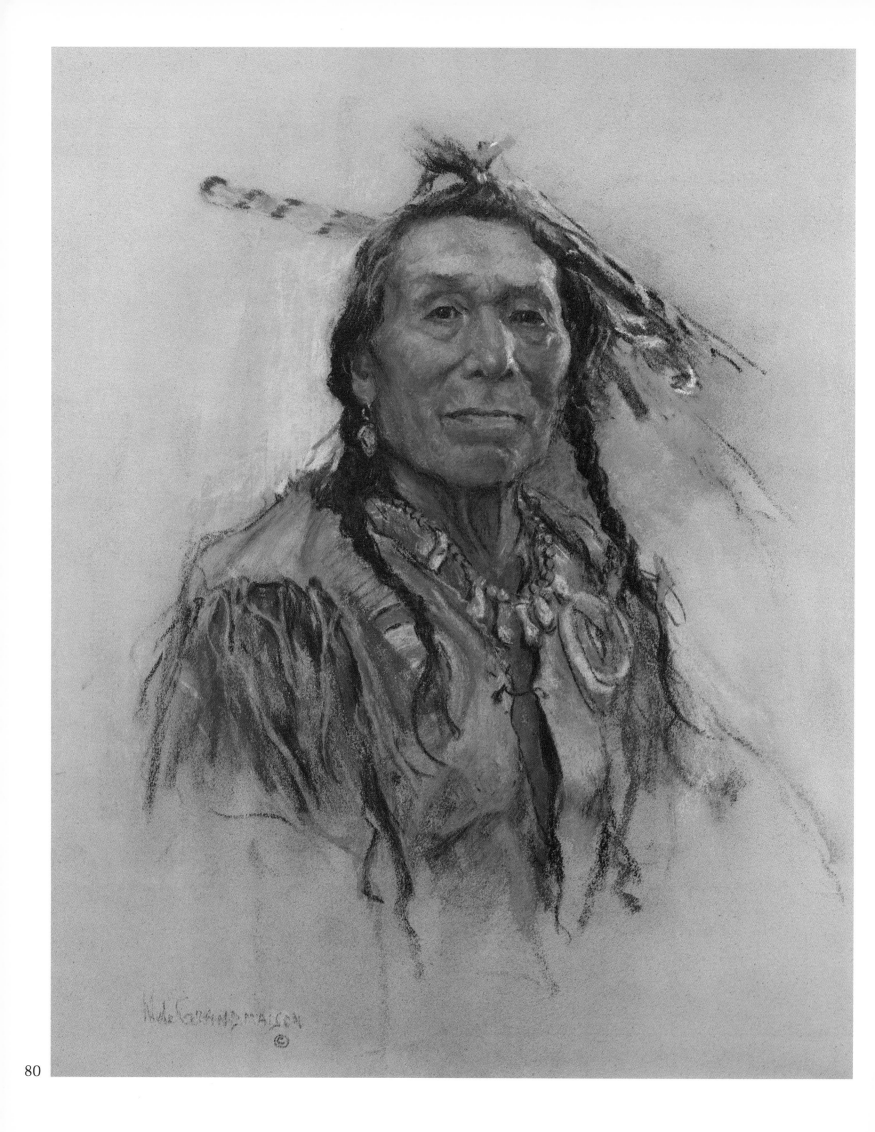

29
Red Cloud, *Ohathi Sa*
Stoney Indian
Morley, Alberta
1943
Pastel on paper, 50 x 63 cm

30
Child
Peigan Indian
Brocket, Alberta
1945
Pastel on paper, 46 x 62 cm

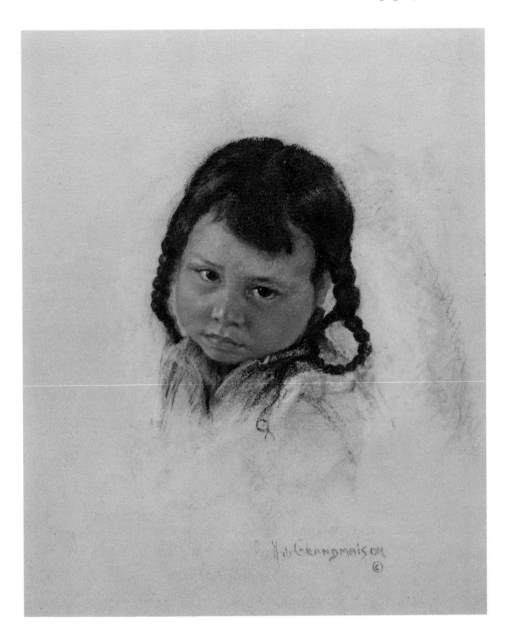

Red Cloud was born in 1875. His mother was a Stoney who had been captured by the Bloods when she was just a girl. After escaping with a Blood woman whose nose had been cut off for unfaithfulness to her husband, the Stoney woman was reunited with her family and later married leader James Dixon. Their son Red Cloud, or Lazarus Dixon, became a rancher and was also a holy man who was chosen to sing sacred songs at the annual Sun Dance. He died in 1951 in a freak tornado near Morley.

31
The Cat, *Poosa*, and Child
Sarcee Indians
Sarcee Indian Reserve, Alberta
1948
Pastel on paper, 46 x 60 cm

32
Coming in Again Woman, *Matsitaipim*
Blood Indian
Standoff, Alberta
1947
Pastel on paper, 56 x 76 cm

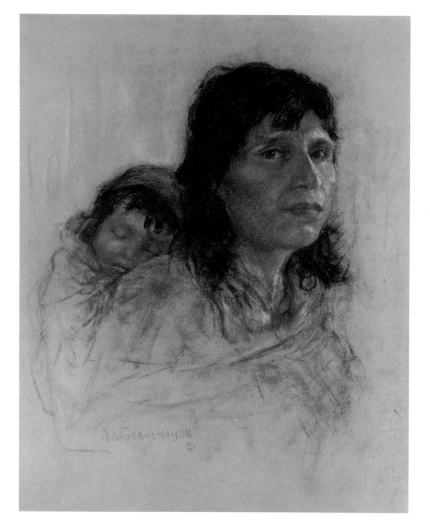

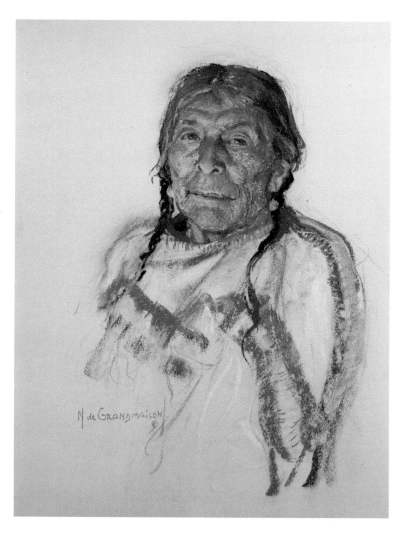

Born in 1888 and christened Jane, *Poosa* was
educated at the Anglican mission school on
the Sarcee Reserve, located on the western
outskirts of Calgary, Alberta. She was a
staunch Anglican and worked on behalf of
her church. After the death of her husband
Charlie Crowchief in 1937, she married Dick
Knight, also from the reserve. She died in
the 1950s.

Born in 1874 and christened Anna, Coming
in Again Woman married a Blood named
Crow Spreading Wings. Coming in Again
Woman was the holy woman for seventeen
tribal Sun Dances. She died in 1956.

33
Riding at the Door, *Itsoksi-ksisto-kitopi*
Blood Indian
Cardston, Alberta
1948
Pastel on paper, 56 x 70 cm
See also figures 44 and 63

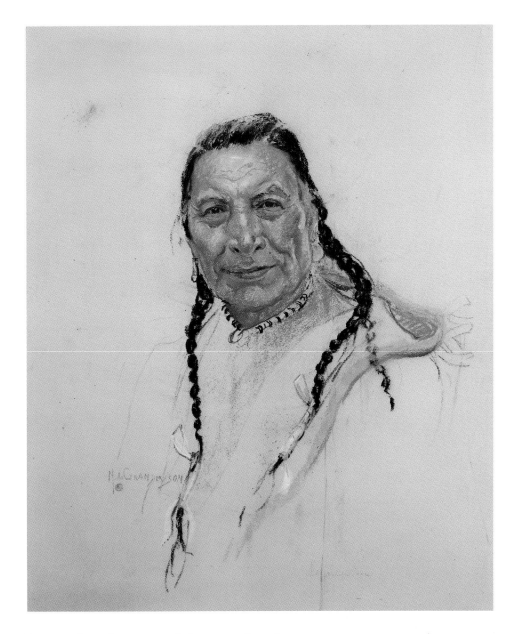

Remembered as one of the most handsome
men on the reserve, Riding at the Door was
born in 1878. His father Crow Shoe was a
Peigan and his mother a Blood. He received
his name because of a war experience of his
father who had daringly taken a horse from
the front of an enemy tepee, mounted it and
ridden away. When Riding at the Door was
about twenty-six years old, his horse ran
away with him and he was dragged, injuring
his hip. As a result, he always walked with a
slight limp. He was married to Stolen Many
Things (figure 58) and was active in the
religious life of the reserve, owning the
Black Catchers Pipe and belonging to the
Horn Society.

34
Mungo Martin, *Nakepenkim*
Kwakiutl Indian
Victoria, British Columbia
1947
Pastel on paper, 58 x 70 cm

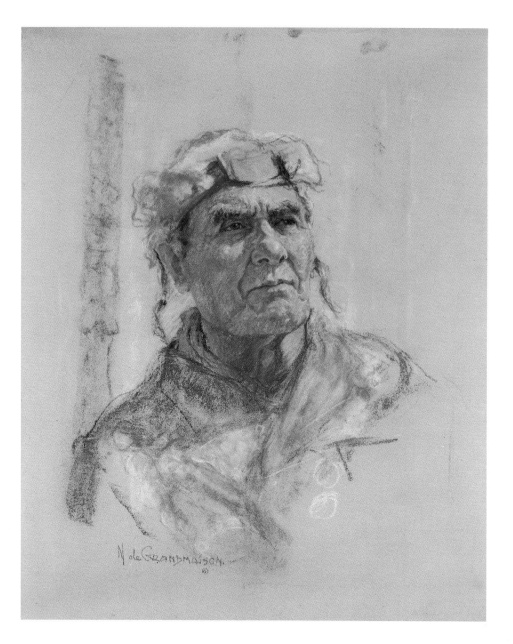

Born about 1879, Mungo Martin was a
Kwakiutl chief from Vancouver Island,
British Columbia. Tutored in the art of
carving wood by his stepfather Charlie
James, Martin followed the age-old
traditions of his tribe in producing massive
totem poles. He trained carvers like his
son-in-law Henry Hunt and his grandson
Tony Hunt. Mungo Martin died in 1962 and
was posthumously awarded the Canada
Council Medal in recognition of his long and
distinguished achievement in the arts.

35
Going to Be a Woman, *Aya-i'kapyaki*
Blackfoot Indian
Gleichen, Alberta
1941
Pastel on paper, 31 x 43 cm

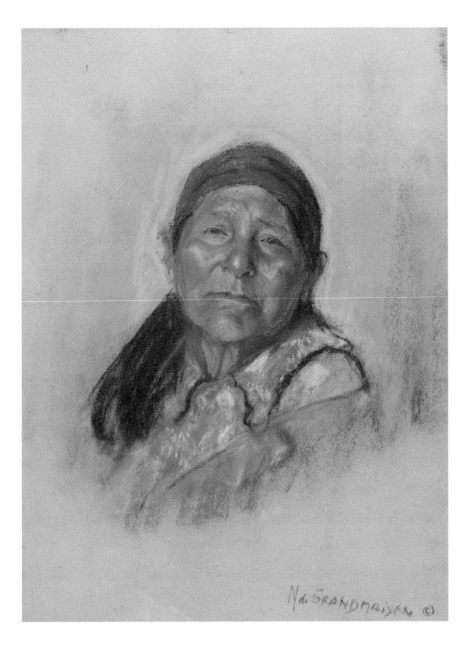

Christened Louise, Going to Be a Woman
was one of a group of Crees who
intermarried with the Blackfoot. She became
the wife of Francis Black and was a faithful
member of the Catholic mission on the
Blackfoot Reserve.

36
Man
Blood Indian
Standoff, Alberta
1948
Pastel on paper, 46 x 61 cm

37
Jimmy Johns
Nootka Indian
Nanaimo, British Columbia
1947
Pastel on paper, 52 x 74 cm

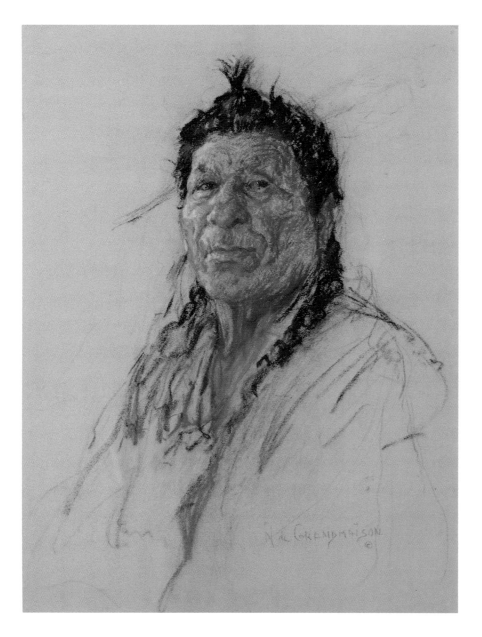

Jimmy Johns was born in 1883 at Friendly Cove on the west coast of Vancouver Island, British Columbia. He started to carve at the age of twelve and produced his first mask at fifteen. Under the tutelage of his father and grandfather, he learned the intricacies of working in red cedar and pine, using themes based upon the legends and traditions of his tribe. His carvings of totem poles, masks and other pieces are in museums throughout the world.

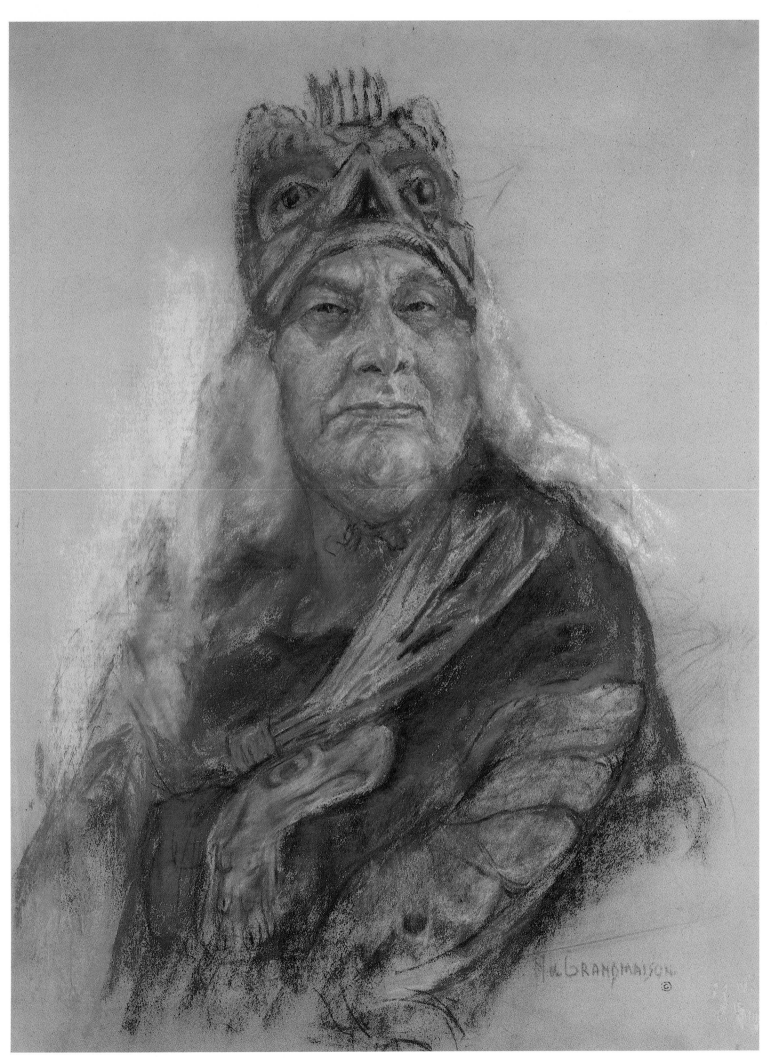

38
Mortimer Eagle Tail Feathers, *Pe'tok-sowatsis*
Blood Indian
Cardston, Alberta
1950
Pastel on paper, 54 x 72 cm

Born in 1887, Mortimer Eagle Tail Feathers was a son of Bull Strong and a grandson of Many Spotted Horses, who in 1877 had been one of the signers of Treaty Number 7 between the Canadian government and the Indian tribes of southern Alberta. Mortimer Eagle Tail Feathers was one of the first students enrolled in the Anglican mission school on the reserve in the 1890s. He had a small farm, with about six hectares planted in wheat, and lived a quiet life. He seldom took part in social activities, being a taciturn man who preferred to keep to himself. He did, however, participate in some religious activities, joining the Horn Society and the Pigeons and All Brave Dogs societies. He died in 1959.

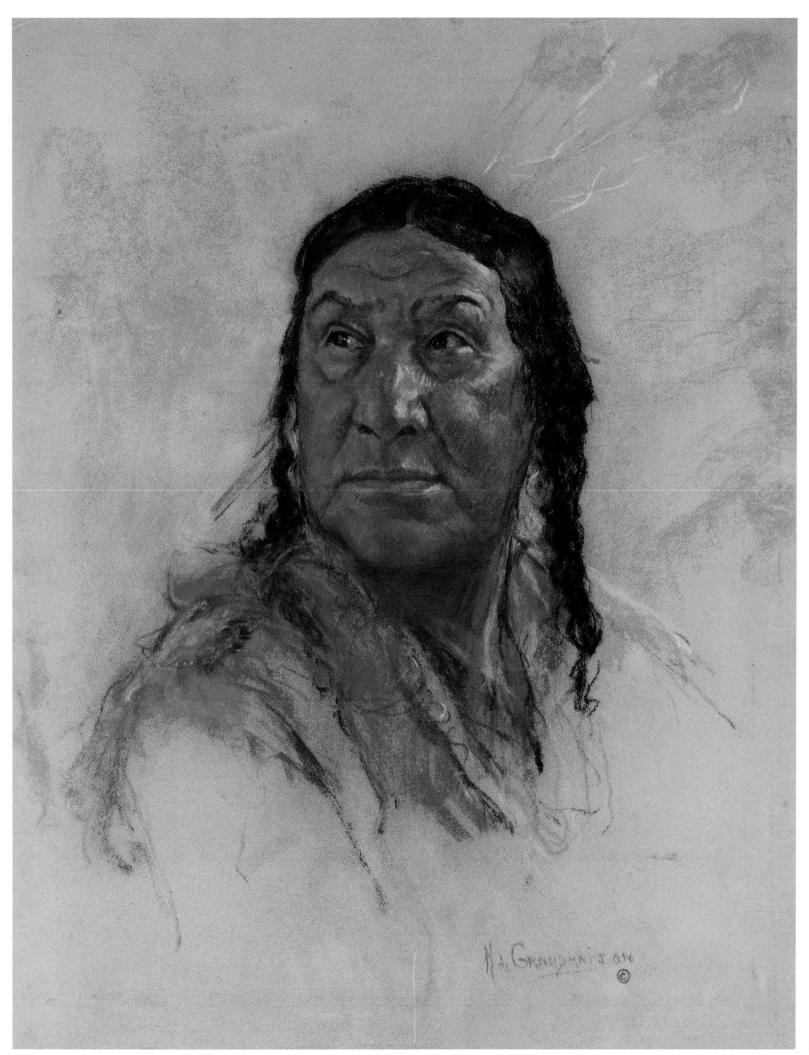

39
Good Rider, *Matso'kitopi*
Peigan Indian
Brocket, Alberta
1954
Pastel on paper, 57 x 82 cm
See also figure 21

40
Walking Buffalo, *Tataga Mani*
Stoney Indian
Morley, Alberta
1950
Pastel on paper, 40 x 50 cm

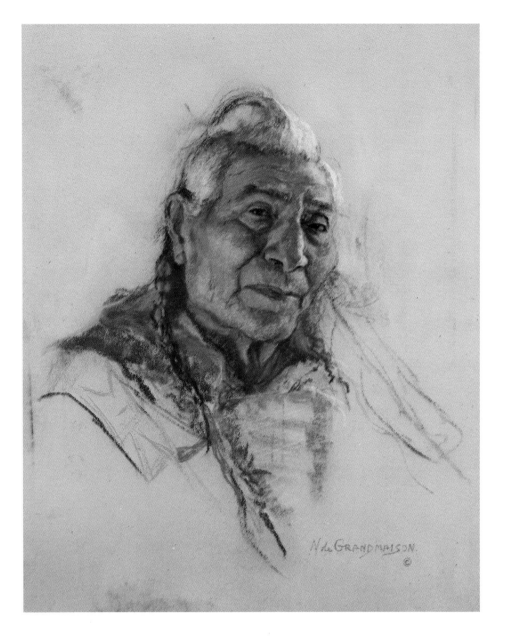

Walking Buffalo, christened George McLean, was born in 1871. After attending a Methodist mission school on the reserve, he was sent away to Winnipeg, Manitoba, for further education and at one time considered becoming a medical doctor. Instead, he returned home where he worked as a teacher, interpreter and police scout, ultimately settling down as a rancher. He married Flora, the daughter of leading chief Hector Crawler. Walking Buffalo was elected chief of the Bearspaw band in 1920 and was a familiar figure at the Calgary Stampede and Banff Indian Days. He died at the age of ninety-six.

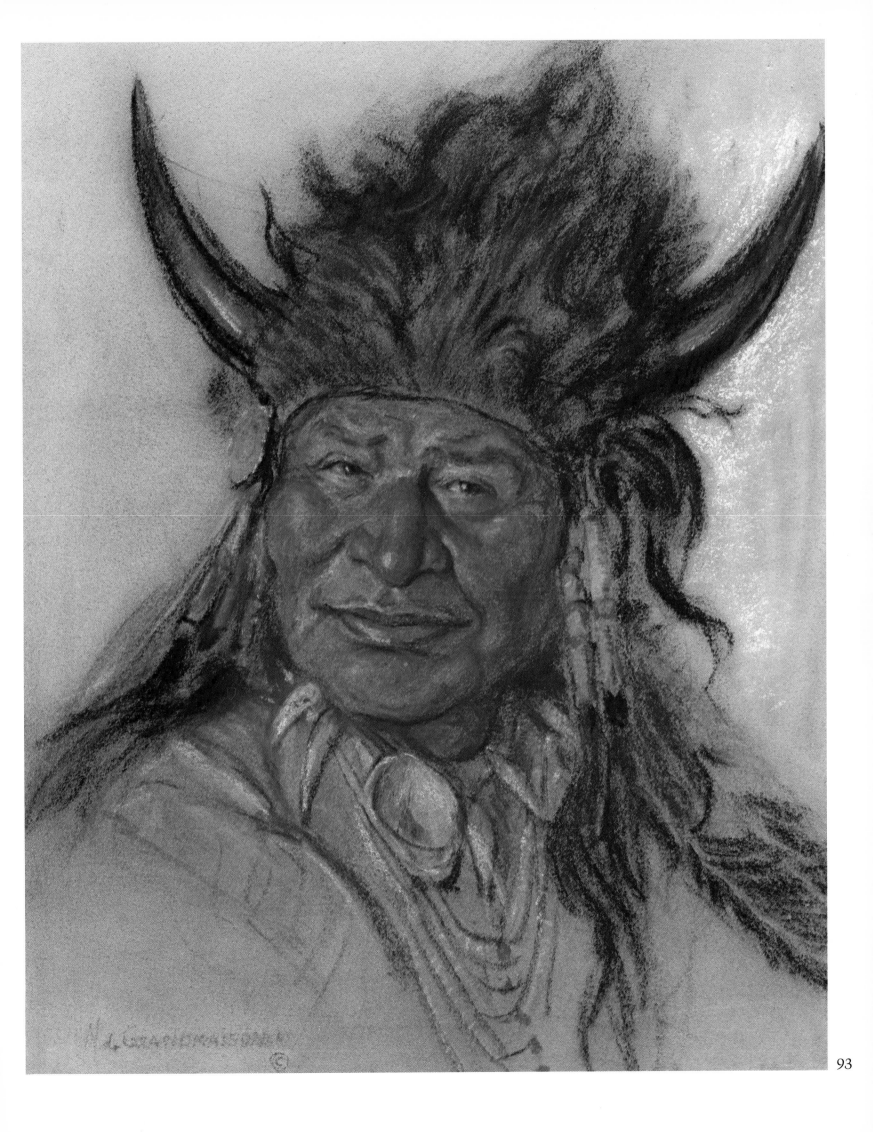

41
Black White Man, *Siksa'pikwan*
Blood Indian
Standoff, Alberta
1957
Pastel on paper, 64 x 84 cm

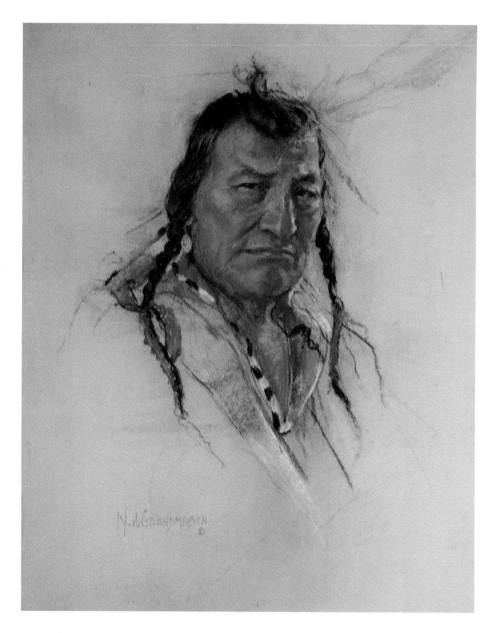

Born in 1879, the son of Wolf in the Water,
Black White Man's name was based upon
the Blackfoot notion that Negroes were
simply dark-skinned white persons. His
name probably resulted from the war
experience of an ancestor. As a young man,
he worked as a Mounted Police scout. In
later years, he participated in the religious
life of the reserve, belonging to the Horn
Society as well as the Doves and the All
Brave Dogs societies.

42
Wears One Moccasin, *Thani-haba Ogihan*
Stoney Indian
Kootenay Plains, Alberta
1950
Pastel on paper, 50 x 65 cm

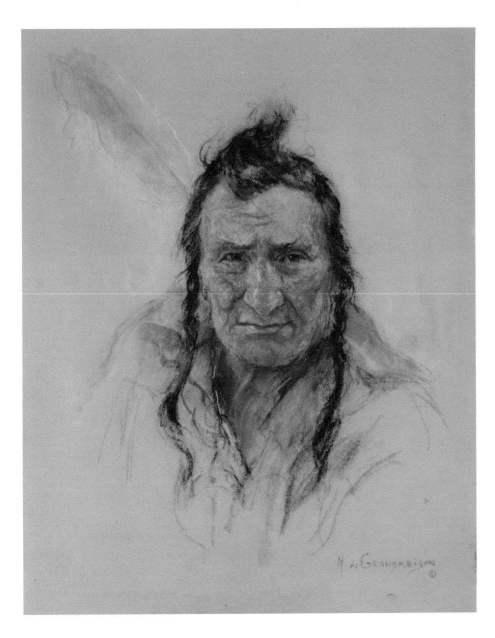

An early convert to Christianity, Wears One
Moccasin was given the name Philip House
by Methodist missionaries. He was part of
the Wesley band which decided to leave
their reserve at Morley, Alberta, about 1894
and move to Kootenay Plains, west of Rocky
Mountain House. Ultimately this area
became the Bighorn Indian Reserve. Wears
One Moccasin served for many years on the
Stoney Tribal Council.

43
Good Man, *Pahkakino*
Cree Indian
Hobbema, Alberta
1954
Pastel on canvas, 65 x 82 cm

44
Riding at the Door, *Itsoksi-ksisto-kitopi*
Blood Indian
Cardston, Alberta
1955
Pastel on paper, 56 x 76 cm
See also figures 33 and 63

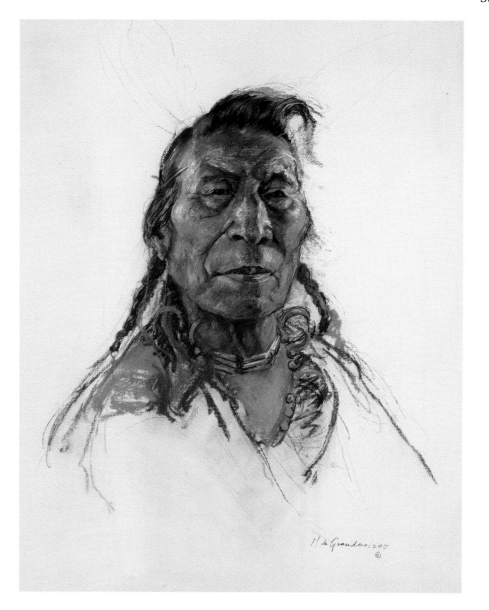

Good Man, or Tom Bull, was a son of treaty chief Muddy Bull who was one of the first leaders to come under the influence of Methodist missionary John McDougall. Muddy Bull led his people to their reserve in the 1880s and became a farmer at the north end of the Bear Hills. Like his father, Good Man farmed and provided leadership for his people, particularly through the Indian Association of Alberta. He was one of the most popular and respected men on the four reserves that made up the Hobbema agency.

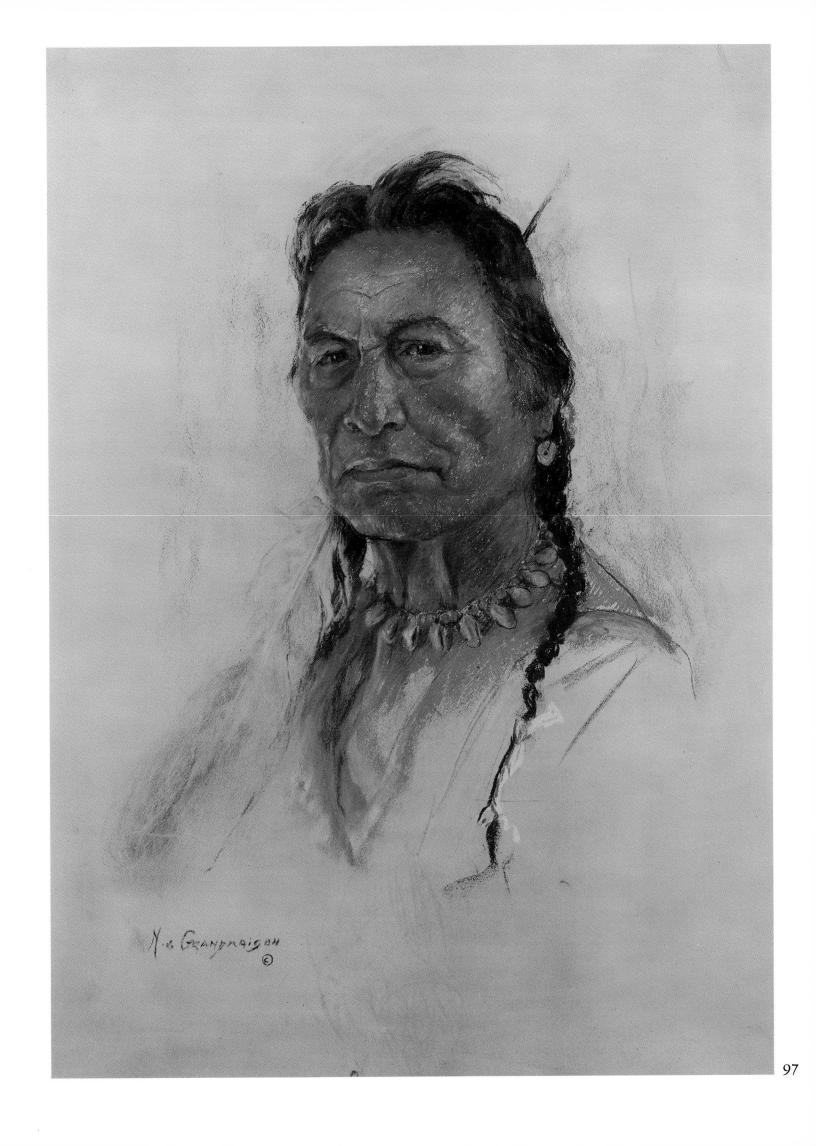

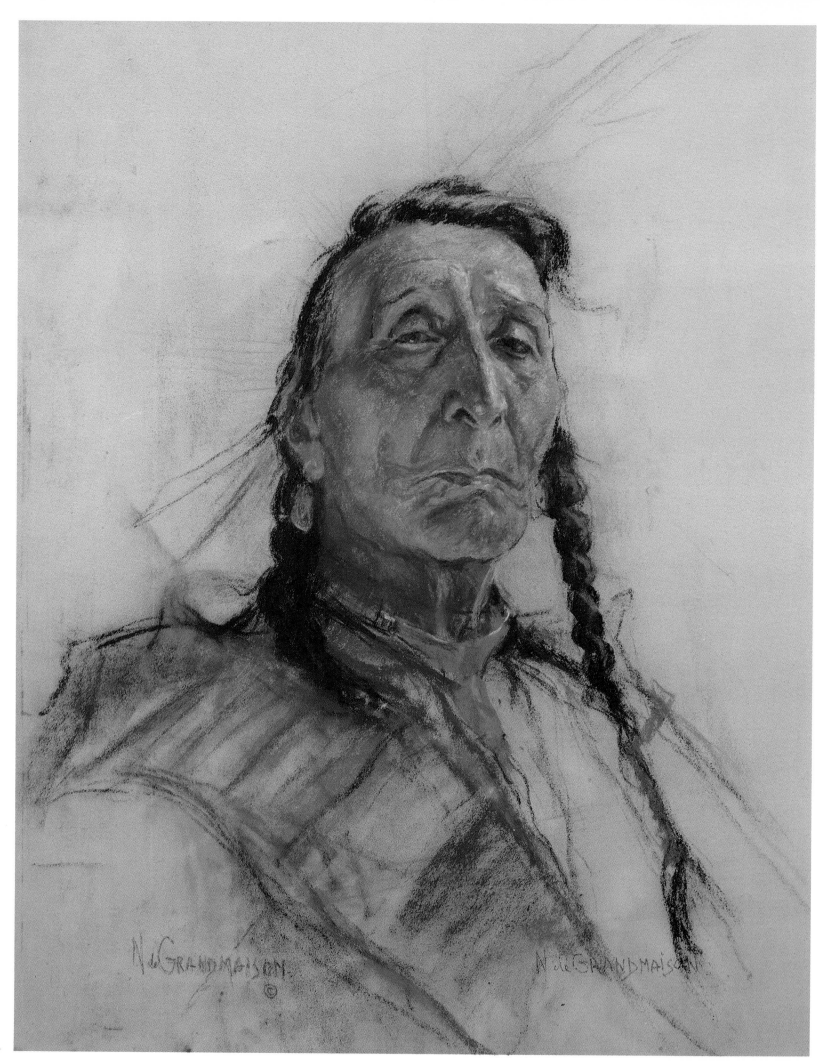

45
Sinew Feet, *A'ksi-pika*
Blood Indian
Cardston, Alberta
1955
Pastel on paper, 62 x 89 cm

46
Man
Cree Indian
Fort Qu'Appelle, Saskatchewan
1951
Pastel on paper, 56 x 70 cm

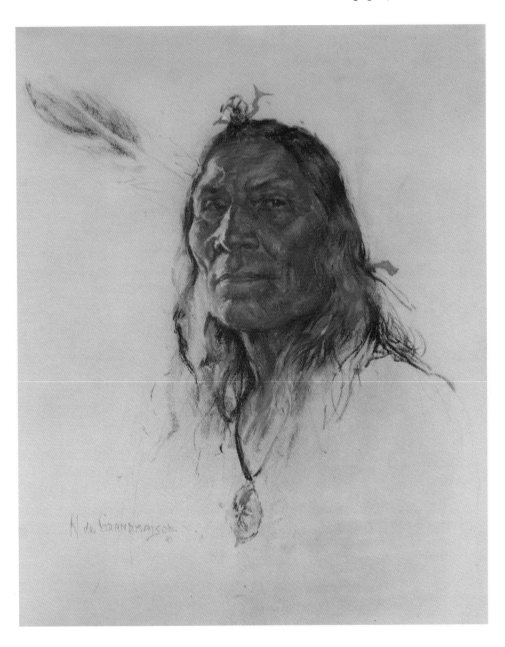

Registered on the government rolls as
Charlie Pantherbone , Sinew Feet was a
successful farmer who retained the religion
and traditions of his people. His grandfather,
Rainy Chief, had signed Treaty Number 7 in
1877 as head chief of the Blood tribe. Sinew
Feet was known as an excellent storyteller.

47
Tough Bread, *Pustam*
Blood Indian
Standoff, Alberta
1952
Pastel on paper, 45 x 62 cm

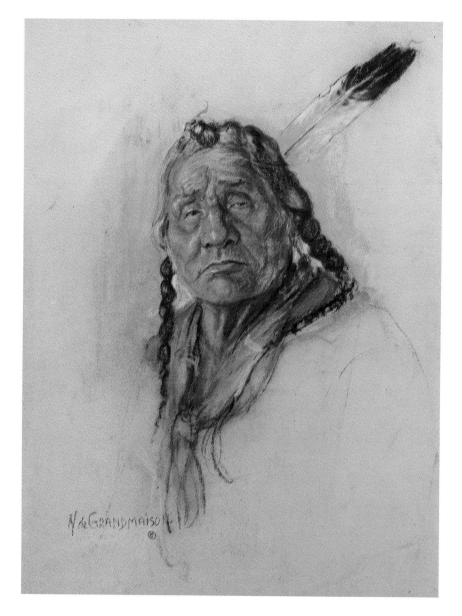

Born in 1869, Tough Bread was also known
as Crooked Forehead. With Longtime
Squirrel (figure 14), he was a member of a
cattle-killing ring in the 1890s and served a
jail term. Tough Bread also served a lesser
term in 1900 for gambling. However, neither
of these offences was considered serious by
the Bloods. Always a religious man, he was a
member of the Horn Society, owned a
medicine pipe, and also belonged to the
Doves, All Brave Dogs, Braves, Black
Catchers, and Crow Carrier societies. At the
time de Grandmaison did this portrait,
Tough Bread was almost blind and lived
with Old Pipe, his wife of many years.

48
Favorite Ill Walker, *Mini't-siko*
Blood Indian
Standoff, Alberta
1955
Pastel on paper, 65 x 76 cm

49
Blue Wings, *Otska'inima*
Blood Indian
Standoff, Alberta
1957
Pastel on paper, 57 x 73 cm

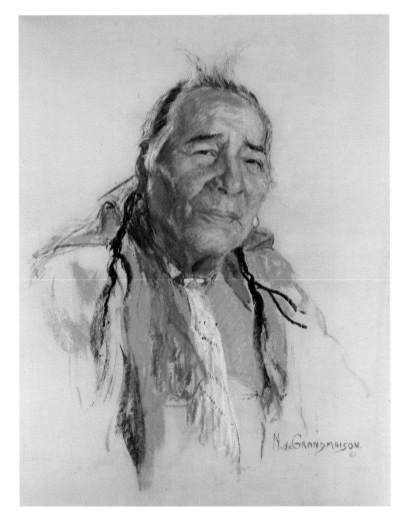

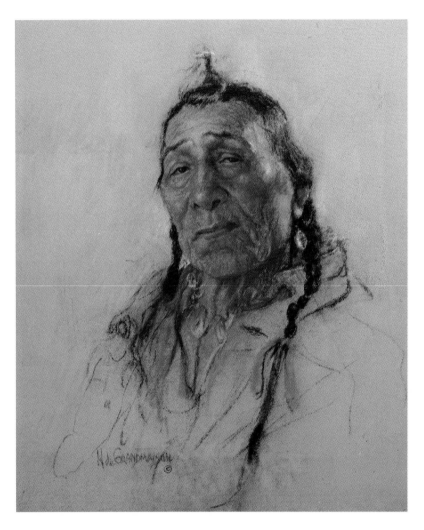

Favorite Ill Walker was the son of a Blood Indian named The Duck and was raised by his uncle Black Bear. After he got a job with the Mounted Police at Fort Macleod, where his work included minding the dogs owned by Superintendent John Cotton, he was given the nickname "Young John Cotton." When he went to the mission school to learn English, Father Lacombe registered him as John Cotton. He went on three horse-raiding expeditions and took part in the last great buffalo hunt of his tribe. Favorite Ill Walker was a member of the Tribal Council for twenty-seven years, a leader in the Horn Society and owner of the sacred beaver bundle for ten years. He died in 1957.

Born in 1870, Blue Wings took part in several horse raids as a young man but later began to breed horses of his own. Four years before de Grandmaison painted this portrait, a reporter had commented: "The only big band of horses left on the reserve is that owned by Blue Wings . . . who has his brand on between 300 and 400 horses. . . . He has not seen many of his horses for years, seldom uses any of them. Some of his friends explained that Blue Wings had never felt the same wealthy person since he was persuaded to sell 600 of his horses in the fall of 1951, very much against his wishes. He refuses to part with any more of his horses." Blue Wings died in 1958.

50
"Trapper at Lac La Ronge"
Cree Indian
Lac la Ronge, Saskatchewan
1957
Pastel on paper, 66 x 88 cm

51
Crow Chief, *Maisto'ina*
South Peigan Indian
Browning, Montana
1952
Pastel on paper, 57 x 77 cm

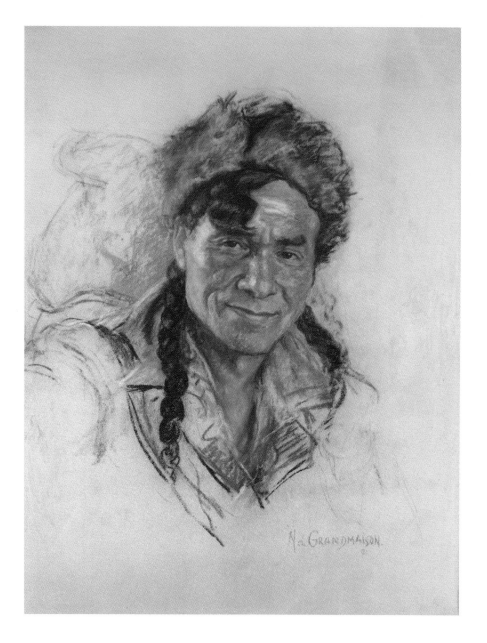

Born in 1876, Crow Chief was a descendant of a Spaniard named Revais who worked for the American Fur Company and had taken a Peigan wife. Over the years, his name was corrupted to Reevis, and when Crow Chief was baptized he was given the legal name of Charlie Reevis. Crow Chief became a successful rancher, supported native religion, and served for almost half a century as a tribal councillor. Painted by New York artist Winhold Reiss, Crow Chief's face graced many calendars and promotional materials. His second Blackfoot name was Returning with a Coup.

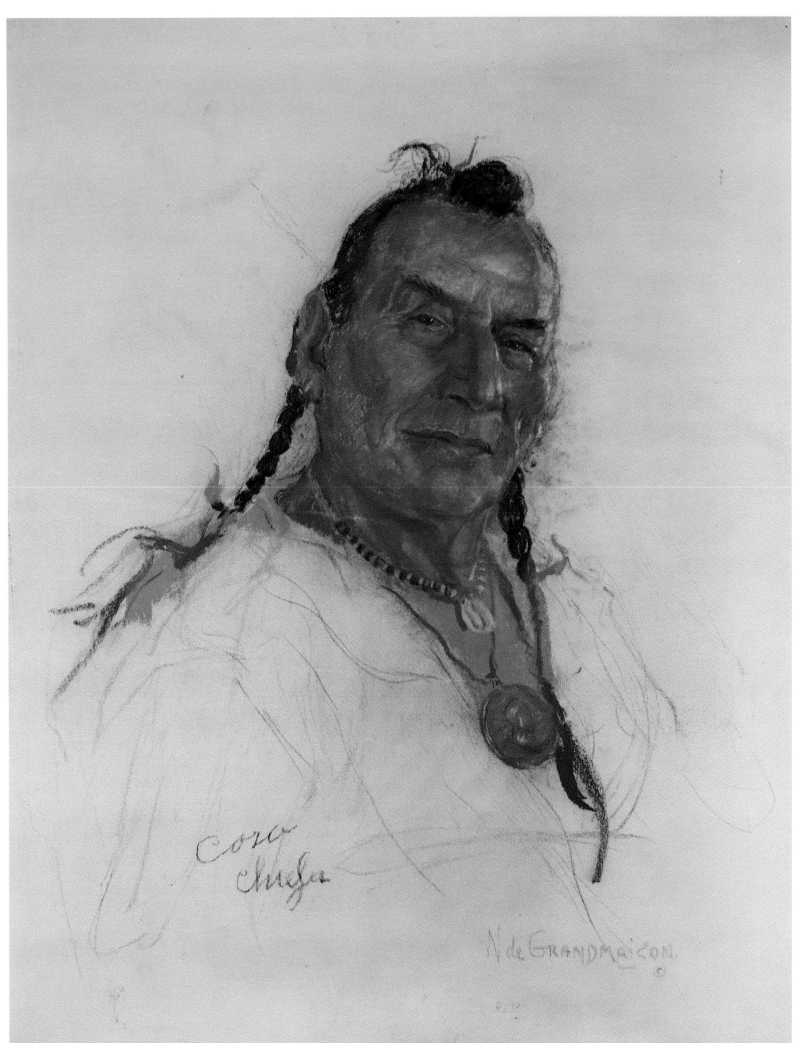

Cow
Chief

N de GRANDMAICON.

103

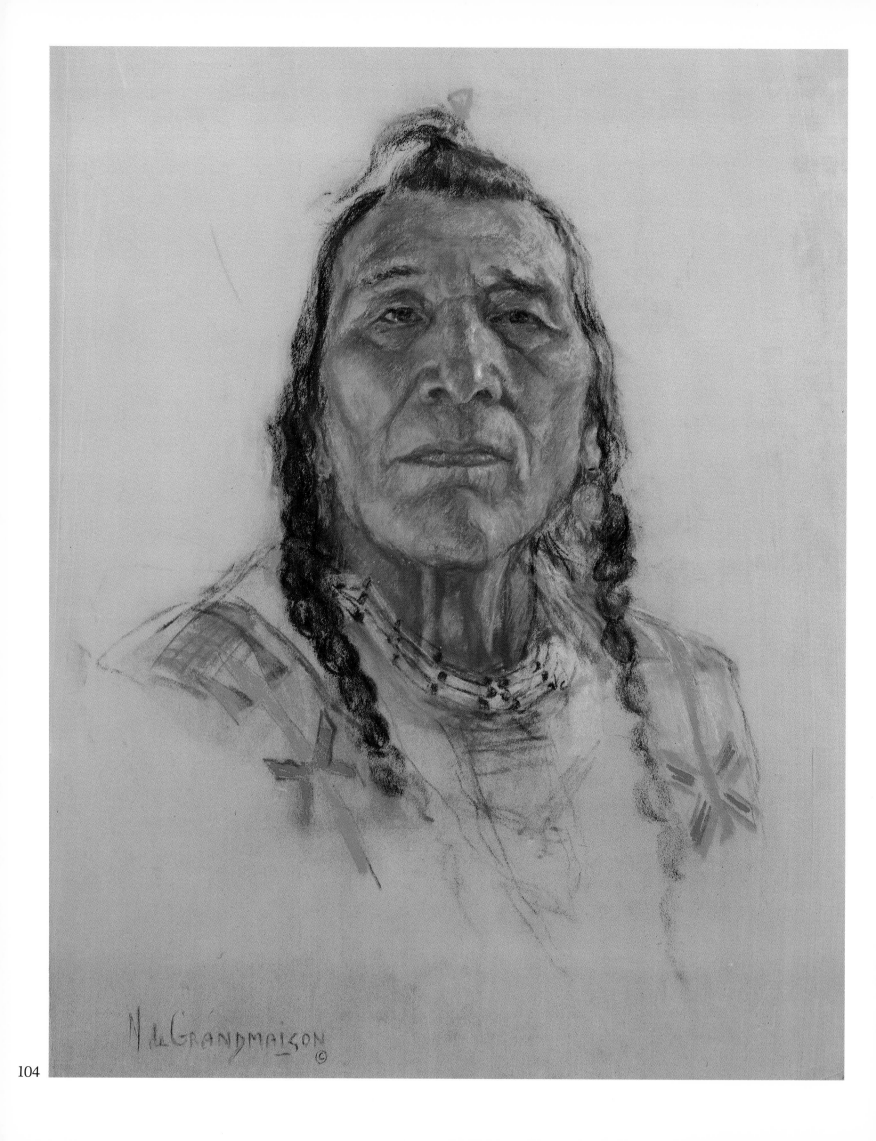

N. de GRANDMAISON©

52
Wolf Tail, *Apisoh'soyi*
Peigan Indian
Brocket, Alberta
1959
Pastel on paper, 61 x 76 cm
See also figures 1 and 55

53
Bull Head, *Peta'saukomaupi*
Peigan Indian
Brocket, Alberta
1959
Pastel on paper, 67 x 86 cm

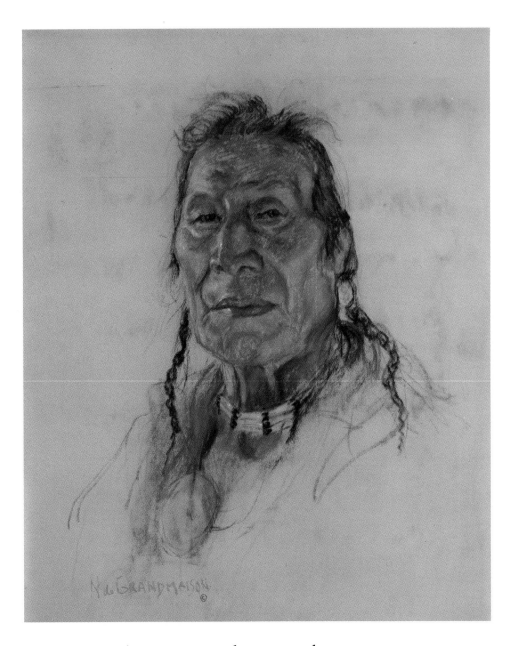

Bull Head was born in 1863 and was named for a relative who was head chief of the Peigan tribe when the North-West Mounted Police came west in 1874. He lived at first with the South Peigans in Montana, then was taken as a child to the Blood Reserve at Brocket, where his name was changed to Bull Head, but he was popularly known as Eagle Young Man. A good friend of de Grandmaison, he was a fun-loving man, a practical joker well liked by everyone who knew him.

54
Hungry Crow, *Maitsto'notsi*
Blood Indian
Cardston, Alberta
1958
Pastel on paper, 68 x 86 cm
See also figure 2

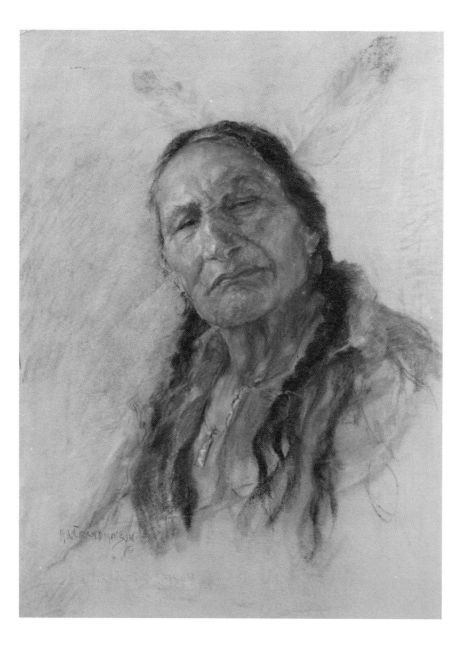

55
Wolf Tail, *Apisoh'soyi*
Peigan Indian
Brocket, Alberta
1960
Pastel on paper, 68 x 86 cm
See also figures 1 and 52

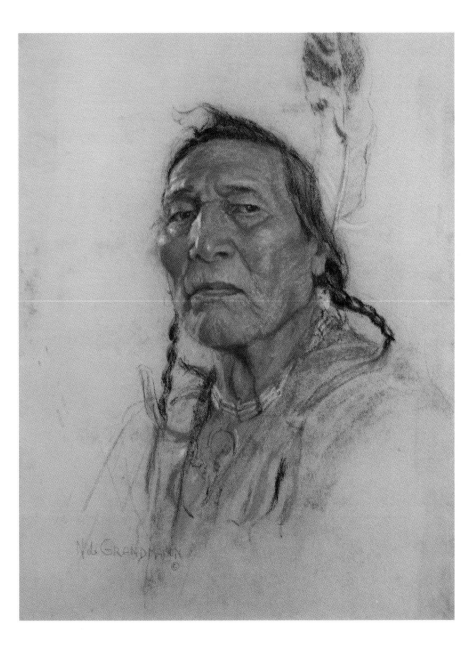

56
Crooked Nose, *Skawakikotayo*
Cree Indian
Hobbema, Alberta
1953
Pastel on paper, 58 x 84 cm

57
One Gun, *Nitai'namuka*
Blackfoot Indian
Cluny, Alberta
1953
Pastel on canvas, 63 x 81 cm
See also figure 23

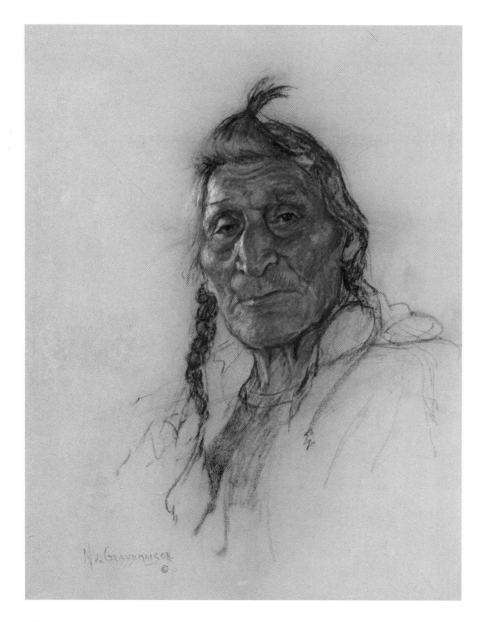

Christened Louis Straw Hat, Crooked Nose
was a member of the Montana band at
Hobbema, Alberta, and was known as a great
storyteller. He died about 1965.

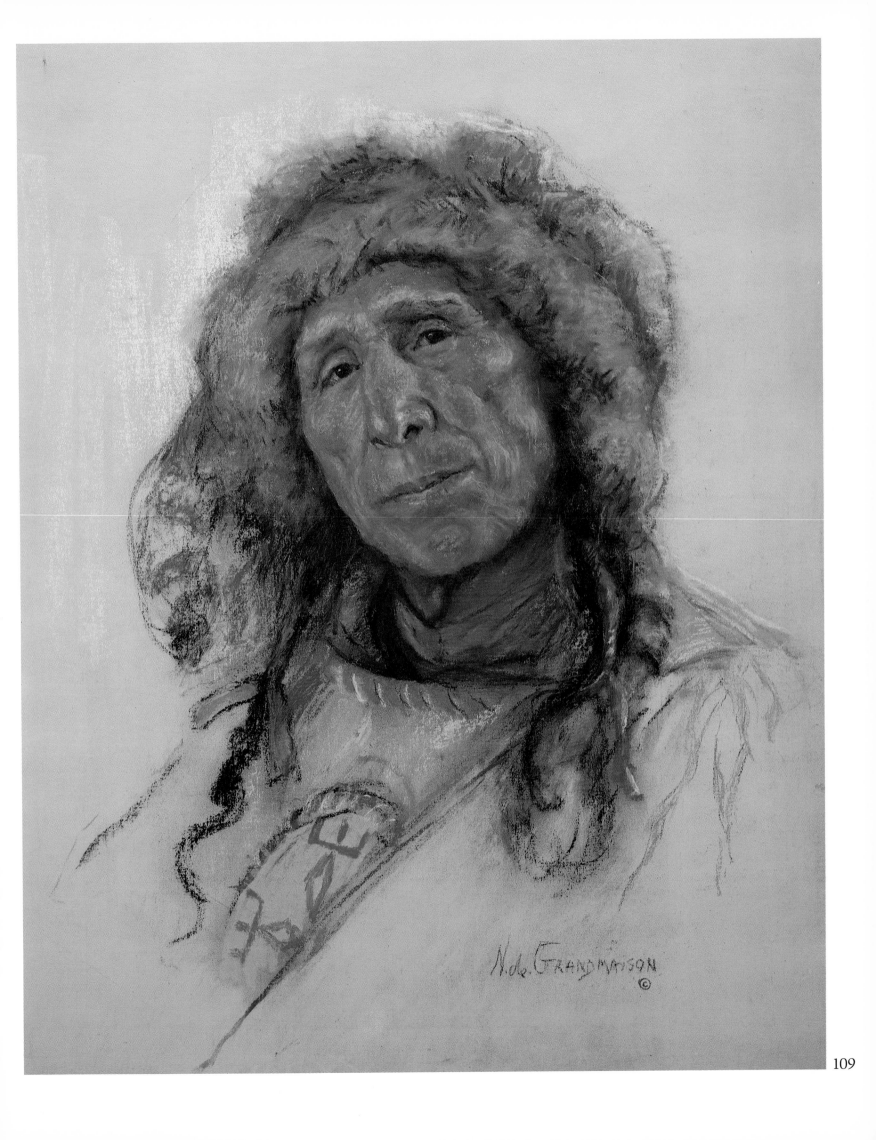

N. de Grandmaison

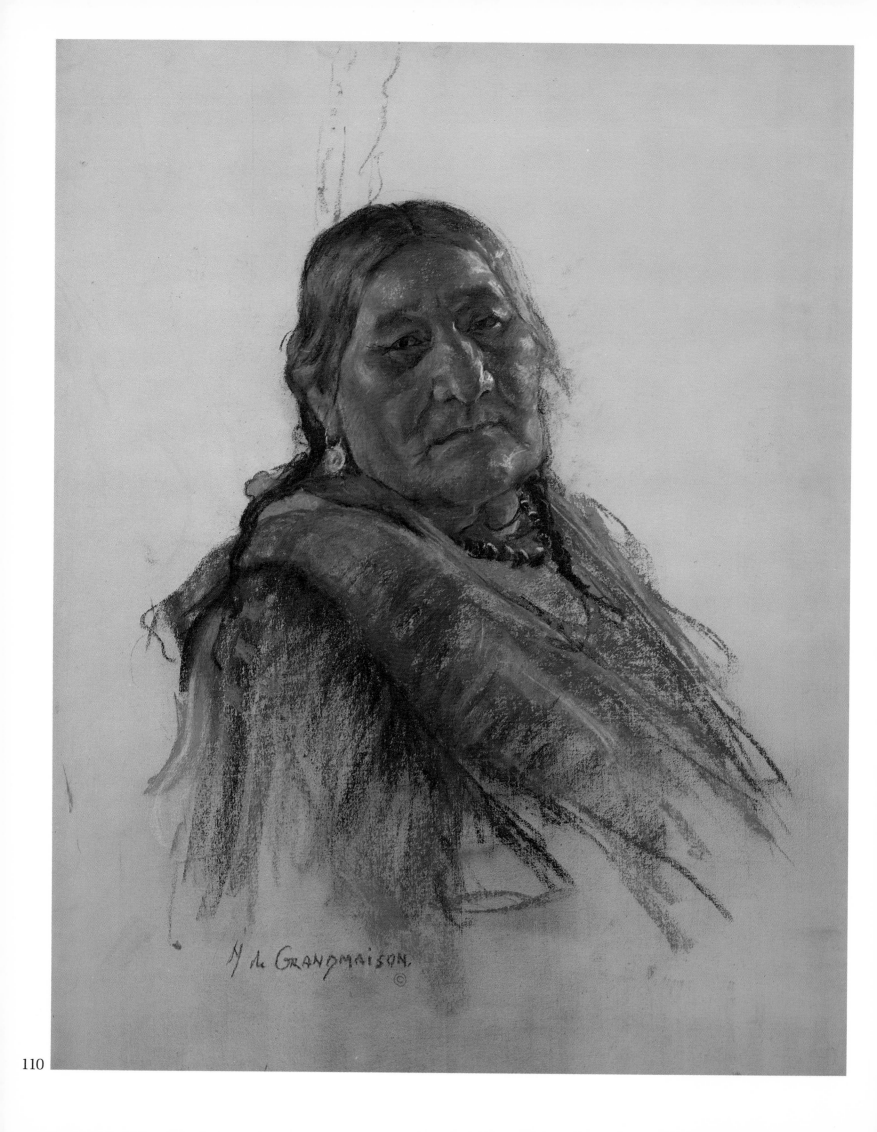

N de Grandmaison.

58
Stolen Many Things, *Aka-kamoosaki*
Blood Indian
Cardston, Alberta
1955
Pastel on canvas, 67 x 88 cm

59
Man
Blackfoot Indian
Gleichen, Alberta
1951
Pastel on paper, 53 x 75 cm

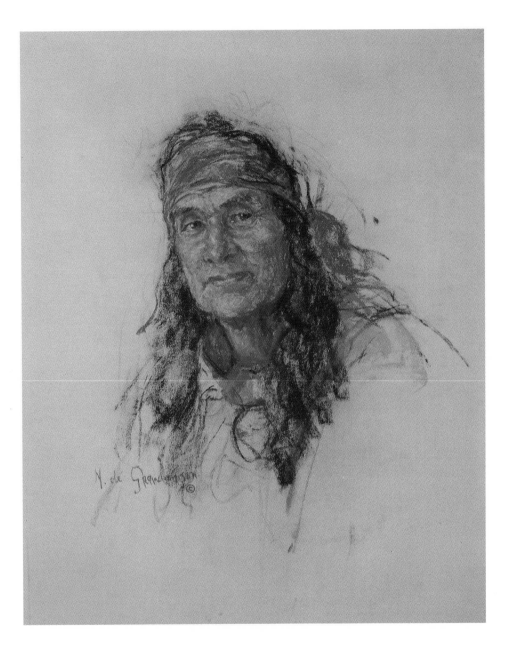

Born in 1895, Stolen Many Things was christened Emma and later married Riding at the Door (figure 33). She became famous as a holy woman of the Blood tribe, sponsoring many Sun Dances and travelling to neighboring reserves to teach the ceremonies to others. Her last ritual took place in 1980 when she initiated a sixteen-year-old girl as a holy woman in Montana. A fellow Blood described Stolen Many Things as a person who "exemplified humbleness, generosity, warmth and, most important, a sense of humor. Both young and old went to her for spiritual advice and guidance." She died in 1981.

60
Longtime Pipe Woman, *Mesamakoyinimaki*
Blood Indian
Glenwood, Alberta
1952
Pastel on paper, 56 x 74 cm

61
Child
Pima Indian
Gila River, Arizona
1951
Pastel on paper, 50 x 66 cm

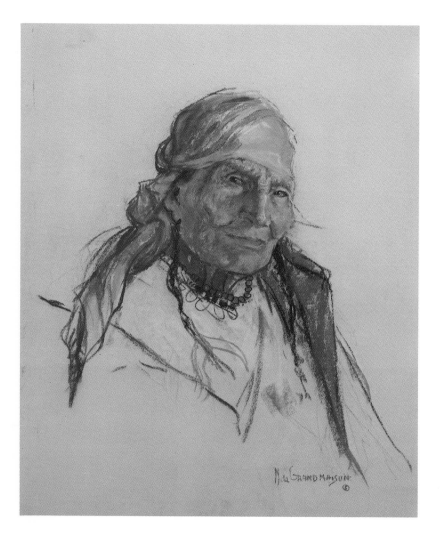

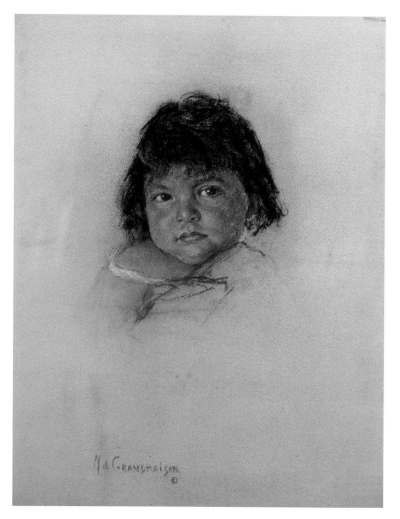

Longtime Pipe Woman was born in 1869 within a short distance of the whisky post of Fort Whoop-up, Alberta, and was a baby when the Blood camps were attacked by Crees in 1870. The raid erupted into the last major battle between the two tribes, ending with the defeat of the Crees. Longtime Pipe Woman became the wife of the Blood head chief Shot Both Sides (figure 19), and the two remained devoted companions until she died in 1955. He died a year later.

De Grandmaison painted this little Pima girl during a trip to the southwestern United States in 1952 when he was trying to compile a portfolio of American Indian portraits. The Pimas, who once lived in adobe villages, developed extensive irrigation systems to produce crops of beans, squash and grain in the arid desert region. The women of the tribe are famous for their pottery and watertight baskets.

62
Wolf Teeth, *Siktogeja Hithke*
Stoney Indian
Morley, Alberta
1955
Pastel on paper, 53 x 66 cm

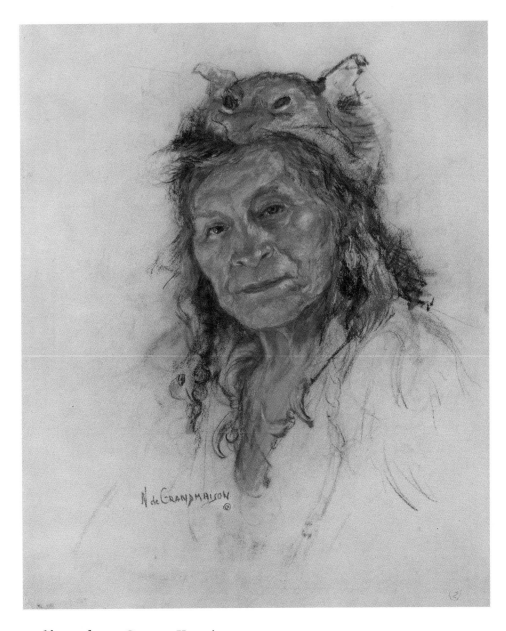

Wolf Teeth, or George Kaquitts, was a
member of the Bearspaw band and a rancher
on the Stoney Reserve. He was a regular
participant for many years in the Banff
Indian Days. As well as being a subject for
de Grandmaison, he was painted in 1922 by
New York artist W. Langdon Kihn. He died
in 1970.

63
Riding at the Door, *Itsoksi-ksisto-kitopi*
Blood Indian
Cardston, Alberta
1952
Pastel on paper, 56 x 76 cm
See also figures 33 and 44

64
White Headed Eagle, *Ubi Thka*
Stoney Indian
Morley, Alberta
1958
Pastel on canvas, 60 x 76 cm

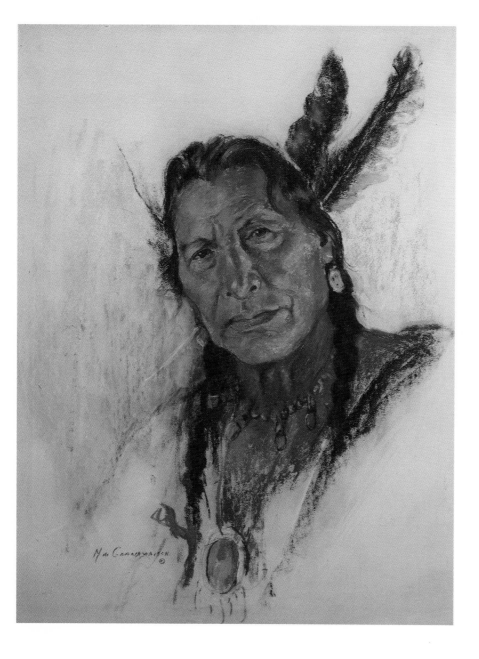

Baptized Paul Francis, White Headed Eagle became a good friend of the de Grandmaison family after they moved to Banff. He visited them at their home, and de Grandmaison helped him when he was sick with rheumatism. Part Cree, White Headed Eagle originally lived on a Cree reserve at Hobbema, Alberta, but went to stay with his uncle Ben Kaquitts in Morley. There he continued to be a hunter and also gained the reputation of being a healer and holy man. He sponsored ten Sun Dances and was active in native religion until his death at the age of ninety.

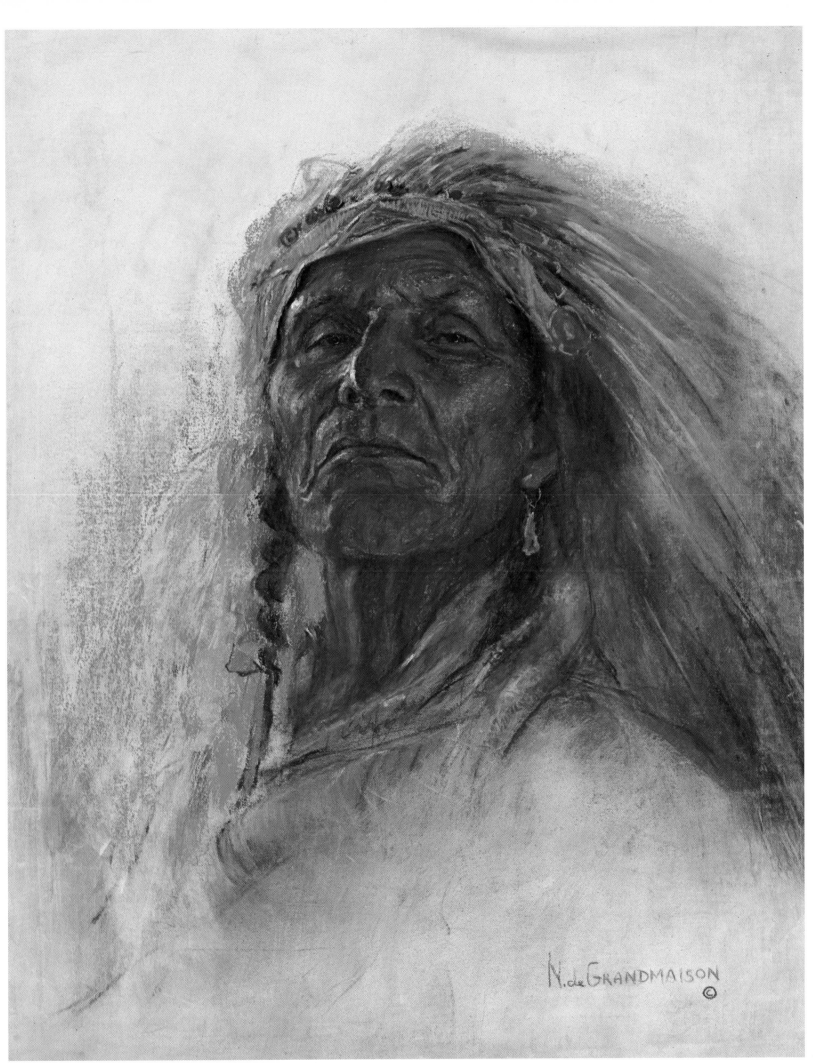

N. de GRANDMAISON ©

115

LIST OF PORTRAITS

The list is in alphabetical order. Bold face digits
indicate figure numbers.

NOTES ON SOURCES

Most of the Indian stories and interviews are from the author's own field notes, dating back to 1953. Information on the artist's life in Europe and his early years in Canada is primarily from material in the de Grandmaison family papers in the possession of Mrs. Sonia Szabados, Regina, Saskatchewan. The direct quotations are from newspaper articles, reminiscences, interviews and private letters. The sources of these are given in the order in which the quotations appear.

NICHOLAS DE GRANDMAISON

"I do hope . . ." (letter, Lady Ivy Dundas to Nicholas de Grandmaison, 22 July 1921, de Grandmaison papers).

"Feeling a change . . ." (letter, Lloyd Rochester to Jack MacKenzie, 13 December 1979, Bank of Montreal papers).

"dusted him off . . ." (ibid.).

"I do not paint . . ." (*Regina Leader-Post*, 1964).

"Sketches of this kind . . ." (*Winnipeg Evening Tribune*, 22 March 1930).

"in these dark faces . . ." (translation, *Russian Voice*, San Francisco, 16 January 1960).

"Lines merely reflect . . ." (*Edmonton Journal*, 8 October 1959).

"One time . . ." (reminiscences of William and Ethel Wallace, no date, de Grandmaison papers).

"When does the next train . . ." (ibid.).

"You have the most beautiful . . ." (interview by the author with Mrs. Sonia Szabados, Regina, 20 June 1981).

"Guy Weadick and Nick . . ." (letter, Joe Clark to Don Becker, 31 December 1974, de Grandmaison papers).

"If I sold them . . ." (*Regina Leader-Post*, 16 June 1960).

"he is a fine artist . . ." (letter, Guy Weadick to Neil McQueen, 10 January 1950, de Grandmaison papers).

"Thank God . . ." (draft of note written by Nicholas de Grandmaison, 25 June 1965, de Grandmaison papers).

"He came on the reserve . . ." (*St. John's Calgary Report*, 10 April 1978).

THE INDIANS OF WESTERN CANADA

"All the sorrow . . ." (*Regina Leader-Post*, 22 April 1957).

"I love them . . ." (*Edmonton Journal*, 8 October 1959).

"I took part in . . ." (*Lethbridge Herald*, 14 January 1956).

"I remember . . ." (interview by the author with Favorite Ill Walker, Blood Reserve, 15 July 1954).

"I know is true . . ." (interview by the author with Sinew Feet, Blood Reserve, 2 August 1960).

"They were only . . ." (interview by the author with Good Man and Mr. and Mrs. John Rabbit, Hobbema, 14 April 1952).

"Their untouched blood . . ." (*Time*, 23 November 1959 and *Montreal Gazette*, 29 December 1959).

PORTFOLIOS I, II AND III

"Sometimes Indians . . ." (tape recorded
 interview by Nicholas de Grandmaison
 with Big Thunder, no date, de Grandmaison
 papers).

"The Stump was . . ." (article by George H.
 Gooderham, 24 January 1951, Gooderham
 papers, Glenbow Museum).

"The only big band . . ." (*Lethbridge Herald,*
 10 March 1953).

"exemplified humbleness . . ." (*Kainai News,*
 January No. 1, 1981).

PHOTOGRAPH CREDITS

The photographs (in order of appearance) are
reprinted by permission of the following:

Endpapers, Cree Indian camp at the Elbow of the
 Saskatchewan River, 1871 (Public Archives
 of Canada)

Nicholas de Grandmaison and Charlie Crow
 Eagle (Glenbow Museum)

Nicholas de Grandmaison, 1943 (Sonia Szabados)

Nicholas de Grandmaison visiting the File Hills,
 Saskatchewan (Glenbow Museum)

Nicholas de Grandmaison in his studio, Banff
 (Sonia Szabados)

Duck Chief family (Glenbow Museum)

Medicine pipe transfer (Glenbow Museum)

Painting tepee (Glenbow Museum)

Blackfoot Indians, mounted (Glenbow Museum)

INDEX

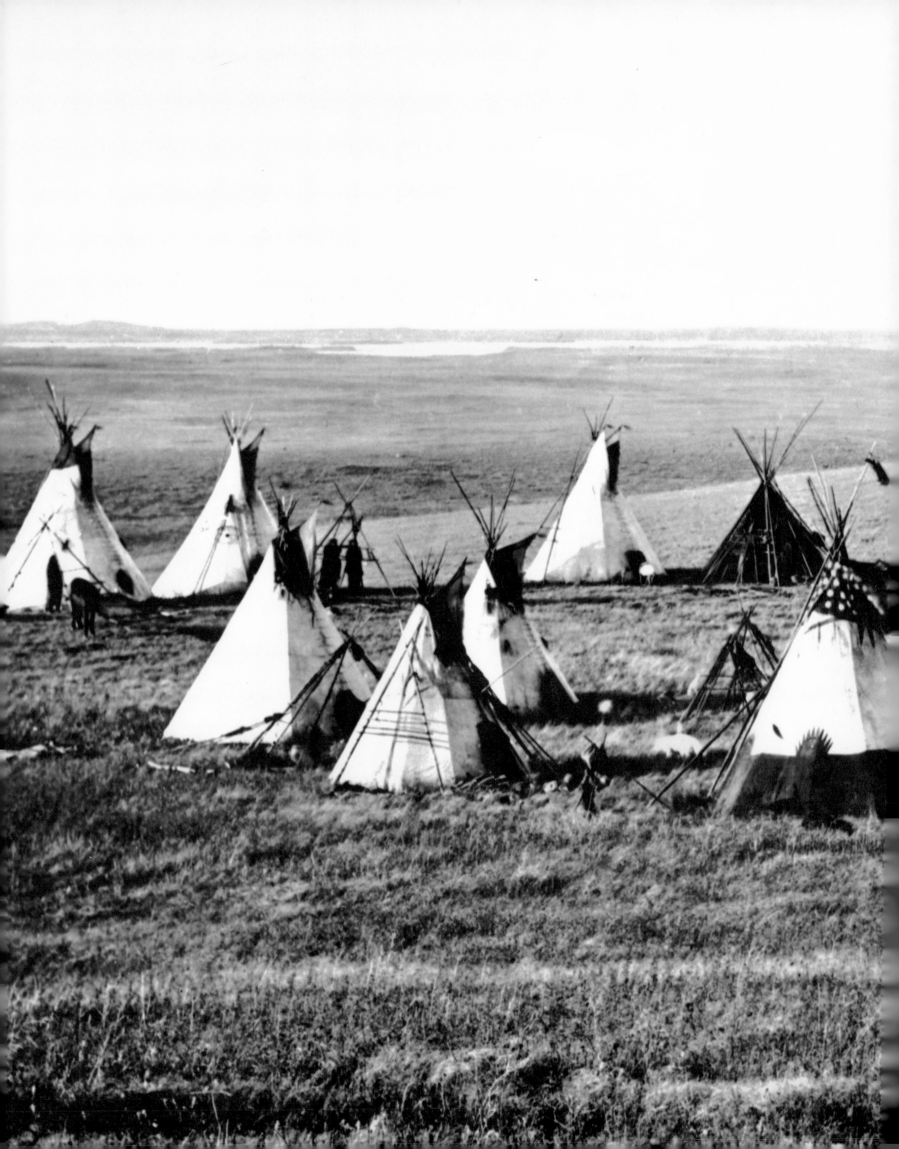